FIGURING MOTION TERRY ROSENBERG

Exhibition Venues

Spazio Krizia,
Milan, Italy

Coral Springs Museum of Art,
Coral Springs, Florida

Gallery of Art and Design,
Southwest Missouri State University, Springfield, Missouri

Bemis Center for Contemporary Arts,
Omaha, Nebraska

ISBN 0-964381-1-3

Vol. VIII, no. 80
Published by Smart Art Press
2525 Michigan Ave, Building C1
Santa Monica, CA 90404
(310) 264-4678 phone
(310) 264-4682 fax
www.smartartpress.com

Distributed by RAM Publications
2525 Michigan Ave, Building A2
Santa Monica, CA 90404
(310) 453-0043 phone
(310) 264-4888 fax
e-mail: rampub@gte.net

Cover detail:
Auto Publik #1, 2001
Mark Jarecke (Ann Hedley)
Oil on linen
76" X 87 3/4"
Private Collection, New York

Photography:
Cathy Carver, Cover and pages 84-92
Larry Ferguson, pages 44,50,51,61,64-71, 74-81, 98-105
John Taylor and Diane Dubler, pages 4-41. 52, 57, 63, 72, 73, 97

Design: LOWERCASE INC. – Chicago
www.lowercaseinc.com

Printed by:
GRAFICHE MILANI Spa

Spazio Krizia exhibition in association with
Orio Vergani / Nowhere Gallery
+ 39 02 8900422
oleoblitz@infinito.it

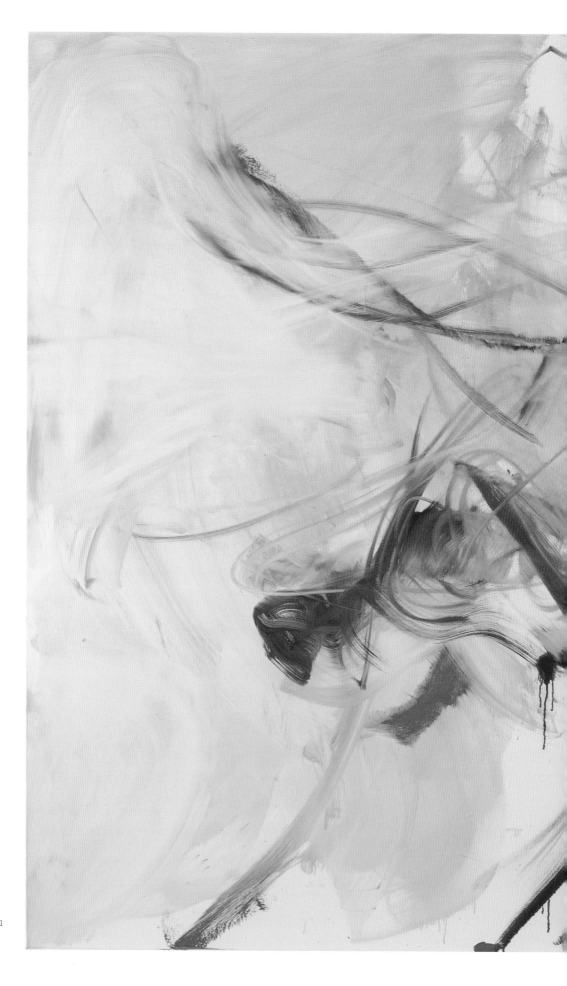

(FIG. 1)

REBECCA #1, 2001
OIL ON LINEN
78" X 110 1/4"

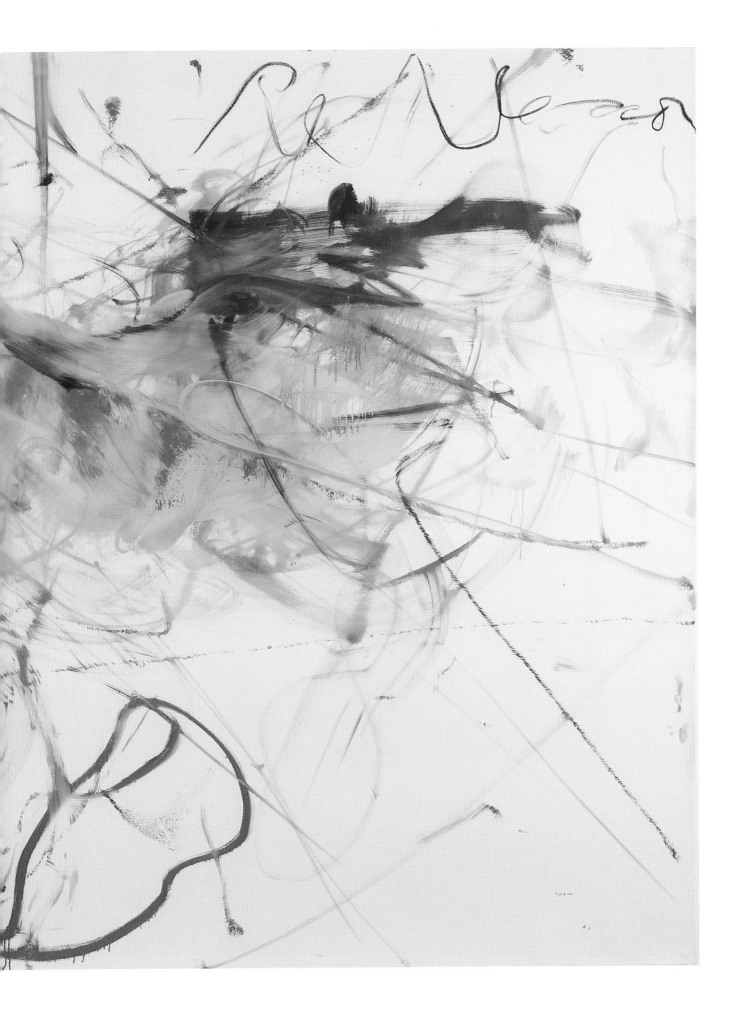

PAINTING THE IMPOSSIBLE

RICHARD KENDALL

Rebecca #1 { FIG. 1 } is a large, voluptuous and radically conceived painting made by Terry Rosenberg in a context which, for almost any other artist, would seem unimaginable. It was executed in New York in 2001, following an idiosyncratic practice he has established in recent years: Rosenberg arranged for a professional dancer — her name provides the title of the picture – to come to his spacious Soho studio, where he had already completed several drawings of her on previous visits. This time, a nine-feet-wide, pristine white canvas was waiting, alongside a battery of paints, brushes, cloths and other devices of his own invention, with which he applies color. Once the two individuals were prepared, the model began to dance, improvising according to her current preoccupations as both performer and choreographer. There had been no rehearsal with the painter or any kind of direction from him. Gradually, their extraordinary collaboration proceeded, at once rigorous and unpredictable, intimate and remote.

As the dancer responded to the music she had chosen, her movements unfolded across the studio floor, while Rosenberg watched her intently from beside his canvas. He has described this process as an intense focusing of his senses and faculties, requiring the absorption of forms and rhythms that now surround him, and readying himself to act in his own arena. At an instinctively chosen moment, the first marks break the whiteness, followed by other urgent lines, veils of color, flourishes of hand and arm, wipings and brushings, all prompted by his fierce engagement with the woman's energy. Soon his painting takes on a dominant hue and a distinctive pattern, all of which might be transformed under further gestures or broad sweeps with rags or sponges, and the search for newly eloquent incident. Simultaneously attending to the dance and to the accelerating evolution of the picture, Rosenberg becomes both the inventor and the observer of an image that now has a defiant vitality of its own. Attacking it and coaxing it, erasing some passages and restating others, he reaches an indefinable point where the cycle seems complete, and puts down his implements. Perhaps an hour has passed, but a new, still unfamiliar form had come into being, a fusion of painting and dance that defies categorization.

Terry Rosenberg's creative project has centered on such original interactions with the ballet and with modern dance for more than 15 years. In the 1980s, after a period of making works in two- and three-dimensions that negotiated between abstraction and the human body, he transferred his concern with visual dynamism to a direct confrontation with the dance. Initially, he produced drawings in charcoal of

female and male performers, ranging from vigorous, gestural studies of torsos and limbs in mid-action to near-vaporous evocations of kinetic events. A parallel group of drawings soon extended this exploration to entire dance ensembles, observed and drawn in rehearsal with the agreement of such companies as Mark Morris Dance Group, The Kirov Ballet, Dance Theater of Harlem and American Ballet Theater. Positioning himself at the edge of their practice spaces and armed with paper, oversize drawing boards, charcoal and pastels, he made high-speed notations of their clusterings and separations, of emerging and dissolving masses in the flow of time. Common to all of them was the encounter with unexpected forms, translated through his dexterity and the instantaneous rapport of eye, hand, and brain into the language of draftsmanship. Drawing has remained fundamental to Rosenberg's practice to the present day, rarely conceived as preparatory in the traditional sense, but essential to the development of his restless language. By 1997, he felt ready to embark on a series of increasingly expansive canvases, experimenting with different grounds, with stretched and unstretched surfaces, and with variously thinned and modified paints, leading to the procedure he favors today.

I first met Terry Rosenberg in the mid-1990s, in the context of an exhibition of ballet works by Degas that I was currently organizing. When he explained the nature of his project, my immediate reaction was to suggest that it was impossible: within seconds, however, I realized that this very impossibility made it irresistible, providing its own source of animation and obliquely novel logic. Because a figure in rapid movement cannot, by definition, be drawn in any conventional sense, let alone be painted, orthodox representation is excluded from the outset. In its place, the artist is obliged to find new means of response and new purposes in his activity, and to re-articulate the nature of his relationship with both dancer and painted surface. If he cannot record what he sees in a given instant, he must engage with the larger subject, with the accumulation of turns and leaps, slidings and archings to the beat of the music, and the emerging tissue of energy that is unique to this performer on one specific occasion. He looks for sympathetic marks in what he has already put down on canvas and for colors that will encapsulate something of the woman or man's presence, even as they reveal themselves to him with the passing of the seconds and minutes. As the dance advances, so his own performance dissolves and re-shapes from one moment to another, pursuing new pictorial variations until it reaches resolution. The outcome is

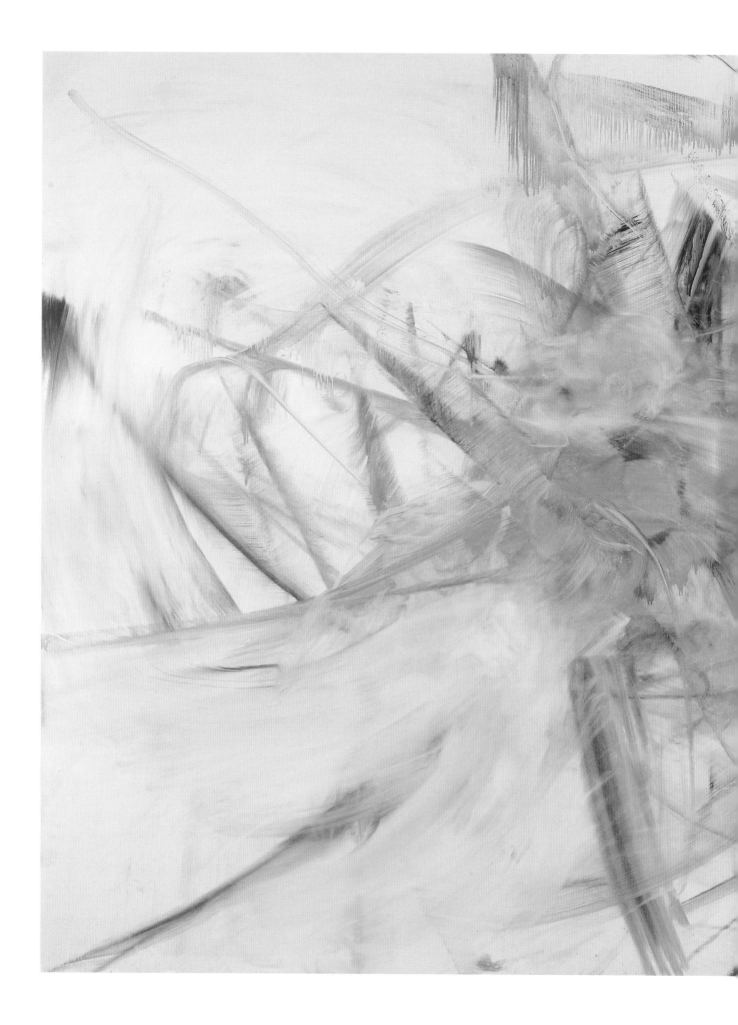

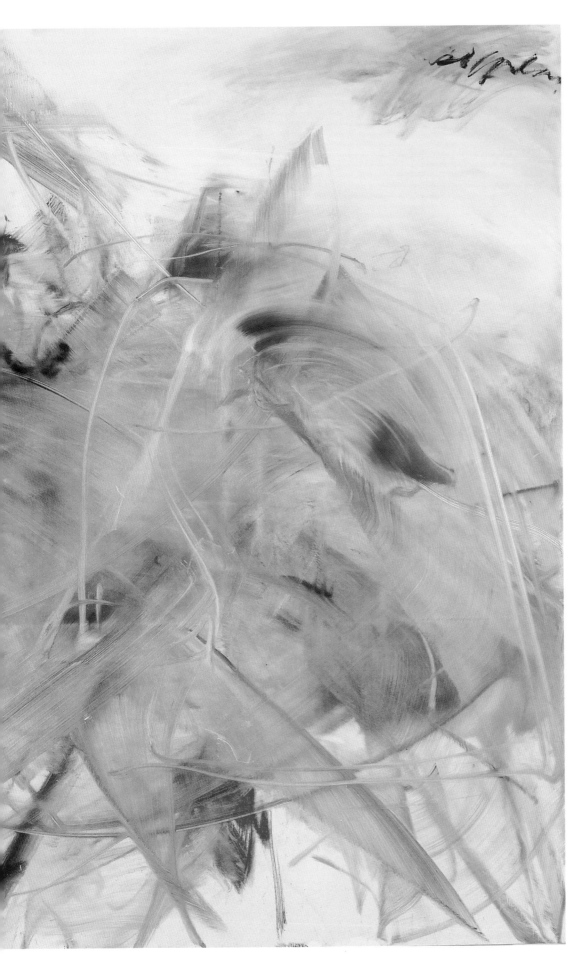

{ FIG. 2 }

SUBDERMAL, 2002
MARK JARECKE / STEFFANY GEORGE
OIL ON LINEN
78" X 110"

neither a portrait nor an arbitrary effusion, but a particularized, intensely felt trace of two energized human beings in conjunction, now summarized in paint.

New artistic enterprises demand new tools, and in time Terry has evolved a graphic and painterly handwriting that is wonderfully appropriate to his self-imposed task. The drawings on paper, some of them more than four feet wide, include not just a rich variety of lines but a repertoire of streaks, smudges, finger prints and impromptu shadows that is augmented on each occasion. Working at high speed, he cannot ponder an effect or calculate his next intervention, but must react instantly, viscerally to the drama transpiring on the stage or in the classroom. These strokes and touches are as much reflexive as cerebral, almost primitive in their force and yet capable of exquisite subtlety. In the large canvases, drawn lines – and their lingering association with precise description – play little part, now replaced by the manipulation of colors in equally unpredictable ways. Determined to break with orthodox facture and its similarly burdensome history, Rosenberg has used fabric, house-painting rollers, and even pads attached to his arms and hands, in addition to a wide range of brushes, to produce eruptions of texture and hue that he hopes will surprise himself. Most recently, as in Subdermal { FIG. 2 }, he has covered the entire canvas with a broadly washed film of a single hue, such as apricot pink or gray blue, into which he introduces bars, strokes and traces of other colors, and from which he can wipe away lighter passages.

As a well-traveled, New York based artist, Terry has many reasons to be aware of the heritage of his activity, both as a technical venture and as a conceptual challenge. Surrounded by the great works of Degas, Eakins and Rodin in the city's museums, he knows how his earlier predecessors were entranced by the energetic body, by the blur and the fragment; in the country that welcomed Eadweard Muybridge, he is reminded of the lure of animals in motion for the pioneer photographers; as a student of the twentieth century, he has absorbed the lessons of Cubism, and of Balla, Boccioni and Severini; and as a long-time resident of Manhattan, he could hardly fail to identify with the heroic days of Abstract Expressionism. This identification can be questioning as well as respectful, allowing him to discover un-mined seams in the rich deposits of the past and new potential for exploration, risk and refinement. The intense seriousness of engagement of the New York School artists echoes deeply through his work, now further problematized – as it was, in different ways, in the careers of Philip Guston, Richard Diebenkorn and Jackson Pollock himself - by the

reintroduction of external stimuli. Confronting Action Painting with the human body in action, and conceived in the most critical terms, Rosenberg has sought to open up a space for a new generation of images.

This determination to push the genesis of his paintings into unknown and barely controllable territory, to make and re-make the imagery under an incessant barrage of sensations, is one of the most audacious aspects of a work like Rebecca. The slightly earlier picture Toshiko of 1999 { FIG. 3 }, demonstrates how such works are literally unthinkable in advance, not just because of the circumstances in which they are made and the lack of standard preparations, but in light of their fluid, mobile character. The astonishing scoops and folds of matter in this canvas, and the explosion of potency at its core, have all emerged from the wayward rituals of painting itself, many of them reformulated several times in the course of a few moments. Rosenberg speaks unforgettably of the state of nervous anticipation that such sessions provoke, and of his frequent uncertainty as they approach the end. More than once, an impending sense of disaster has urged him to obliterate much of what he has achieved, only to find a transcendent palimpsest that supercedes all his previous efforts. His images are rarely revised once the encounter is over, but several days are sometimes needed for him to come to terms with his creation and begin to evaluate it.

License of this kind will always be hazardous, but at this extreme level it holds out the promise of correspondingly extravagant invention, leading to the pulsing exuberance of Rebecca, the tumultuousness of Toshiko, and the haunting, skein-like confection of Mari Angela # 4 { FIG. 4 }. In the latter, an uncharacteristically delicate background of pale pink stains the canvas, bringing the scene as close to sweetness as Rosenberg ever approaches. Equally untypical straight lines articulate this area in several places, perhaps suggesting the perspective of the room yet without insisting on it. Against this fragility, the taut, convoluted gyrations of Mari Angela have left a climactic pattern of dips, peaks and spun brushstrokes that deny its decorativeness. Dragged and smeared paint, whites transmuted into silvers and pewter grays, lacy webs of black and rose combine in a mesmerizing cluster, with a solitary intervention of acid yellow to disrupt their harmony. Other works move in a contrary direction, towards ominous browns across an uninflected canvas or rainbow-like scatterings of primary and secondary hues. But all of them grow out of a similar setting and a

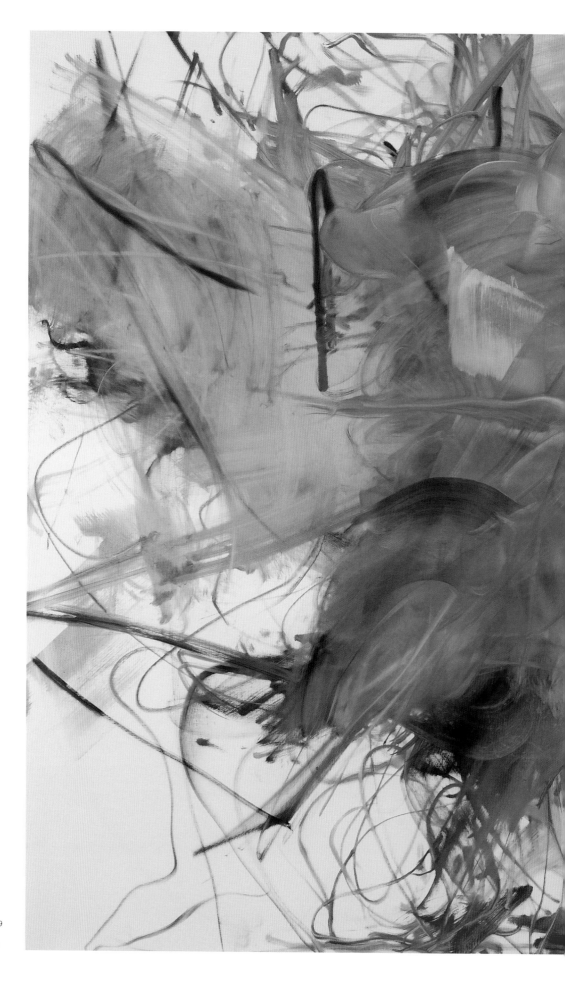

(FIG. 3)

TOSHIKO, 1999
OIL ON LINEN
78" X 110 1/4"

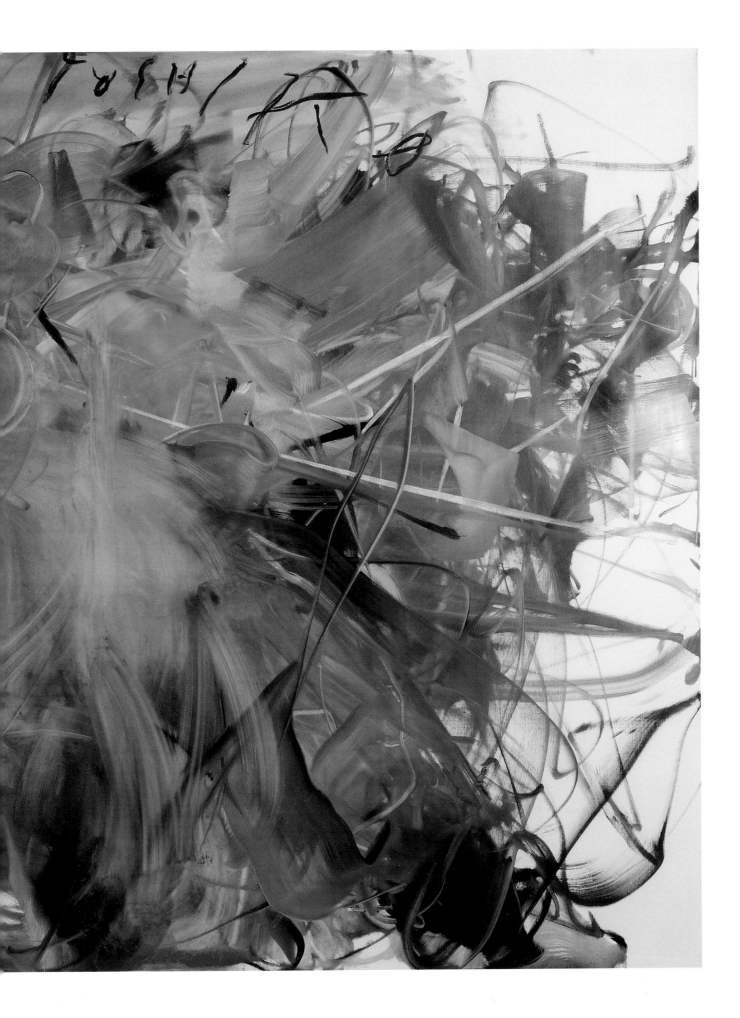

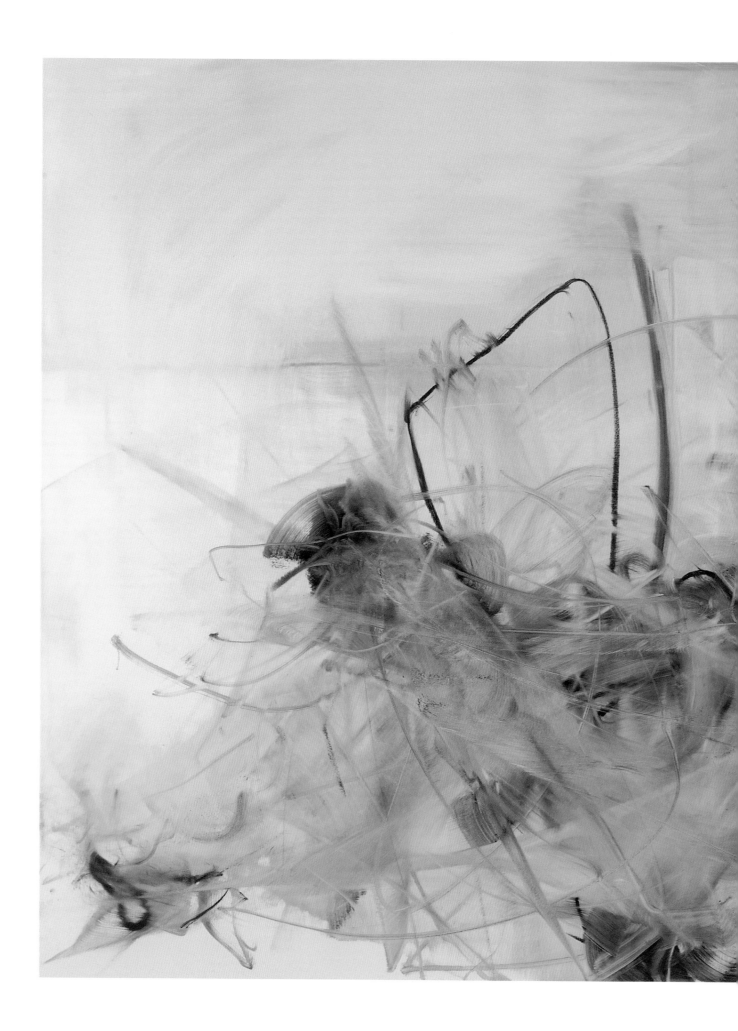

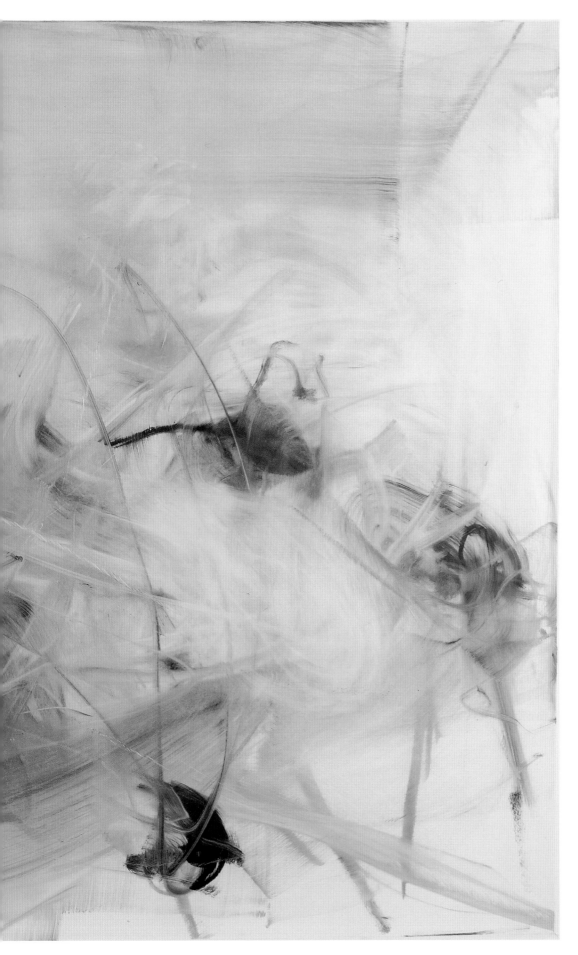

{ FIG. 4 }

MARI ANGELA #4, 2001
OIL ON LINEN
78" X 110 1/4"

comparable procedure, each one the heightened response to a singular animation, to the mysterious chemistry of personality and the exotic physics of paint on canvas.

Fundamental to these encounters is the possibility of new pictorial experience, of pressing at the barriers of visual syntax and expanding the life of painting itself. Some of his completed images are almost shocking in their promiscuous life, bursting out of the constraints of familiar technique as well as the polite protocols of modernism. Even while a creation like Rebecca pays its respects to the bounding edges of the canvas and establishes a buoyant, witty link with them, other works thrust forward out of their frames and seem to deny their planarity. It is hard to convince our eyes, for example, of the flatness of Mari Angela # 4, so intense and massive in its central chromatic force, and so complex its negotiations with its surroundings. Equally, the cutting of the trunk-like organism in Toshiko at the lower margin speaks of immense powers beyond the containing rectangle, as if we peer into forbidden territory or witness an elemental flowering. Rosenberg's endearing habit of writing across his paintings and drawings – most often to incorporate the model's name, but sometimes to include exclamations heard in the dance studio – takes us into yet other dimensions: not just words and sounds are added to his arsenal, but extensions into time and affective space.

The most thoughtful and self-critical of artists, Rosenberg understands the importance of the past as well as the inescapable need to make things new, to revisit his seniors and to be true to his own times. These drawings and paintings grew out of a reflective, deeply held conviction that there is more to say with colors on a plane surface, in ways that involve hazard and extreme commitment. There are few more demanding convictions for a painter to hold, at this or any other date, but it visibly gathers momentum with each of these brave, startling works of art.

Richard Kendall trained as a painter and printmaker before taking an MA in art history at the Courtauld Institute of Art, London. He has published books on Cezanne, Degas, Monet, and Van Gogh and has curated several major exhibitions of the work of Degas in Britain and the United States. He now works as an independent scholar and has written essays and reviews on the work of contemporary artists including Lucian Freud, Howard Hodgkin, and Leon Kossoff.

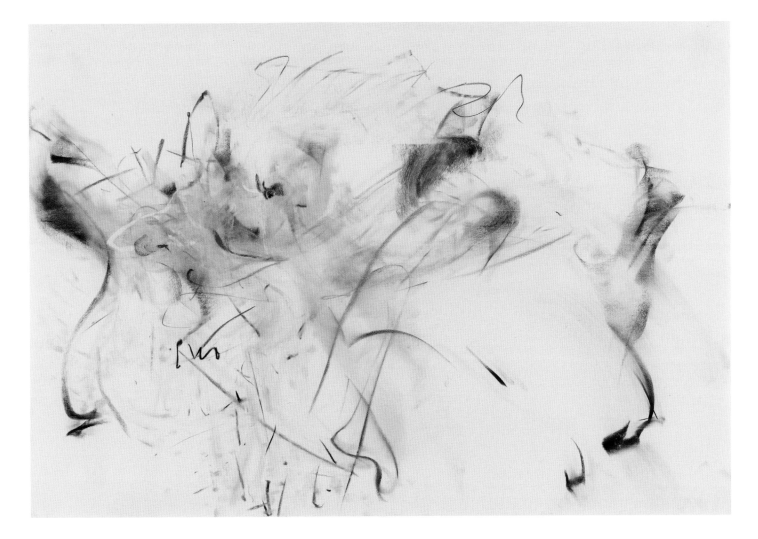

FILLE #4, 2002
AMERICAN BALLET THEATRE (MURPHY/BELOTSERKOVSKY)
PASTEL, CHARCOAL AND GRAPHITE ON PAPER
27 1/2" X 39 1/2"

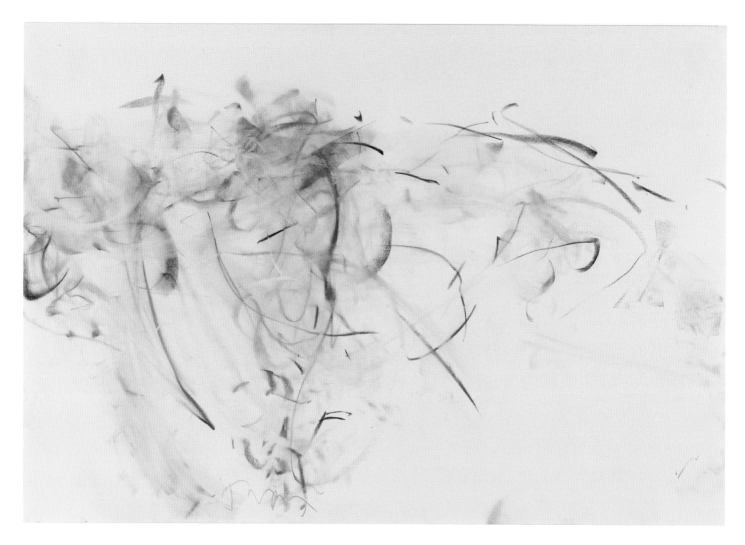

FILLE #6, 2002
AMERICAN BALLET THEATRE (MURPHY/BELOTSERKOVSKY)
PASTEL, CHARCOAL AND GRAPHITE ON PAPER
27 1/2" X 39 1/2"

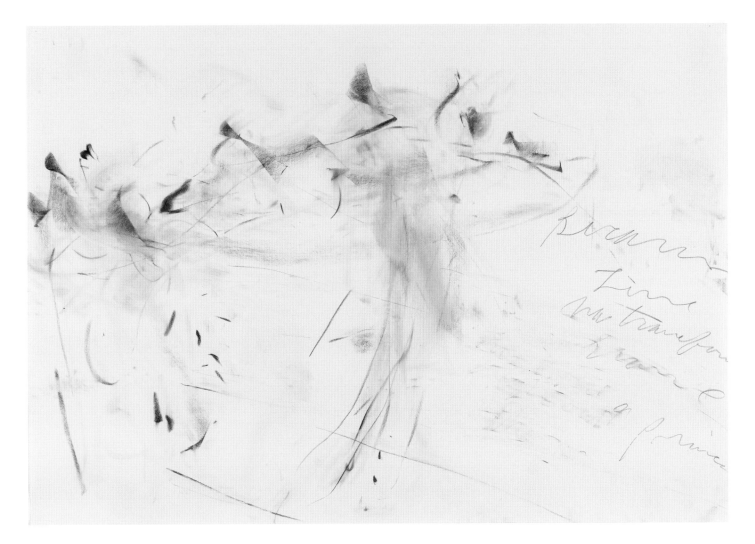

FILLE #7, 2002
AMERICAN BALLET THEATRE (MURPHY/BELOTSERKOVSKY)
PASTEL, CHARCOAL AND GRAPHITE ON PAPER
27 1/2" X 39 1/2"

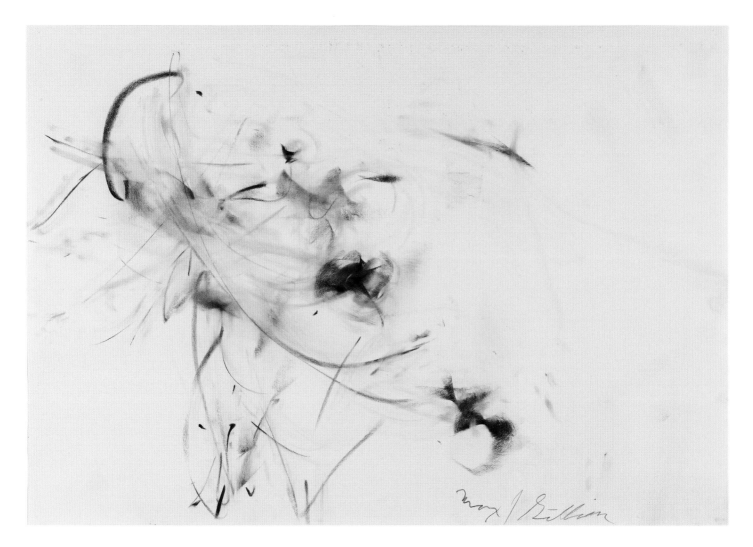

FILLE #8, 2002
AMERICAN BALLET THEATRE (MURPHY/BELOTSERKOVSKY)
PASTEL, CHARCOAL AND GRAPHITE ON PAPER
27 1/2" X 39 1/2"

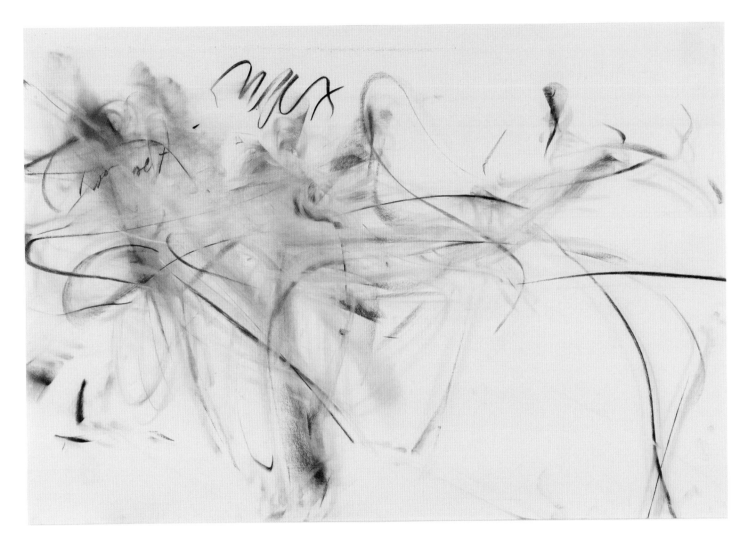

FILLE #5, 2002
AMERICAN BALLET THEATRE (MURPHY/BELOTSERKOVSKY)
PASTEL, CHARCOAL AND GRAPHITE ON PAPER
27 1/2" X 39 1/2"

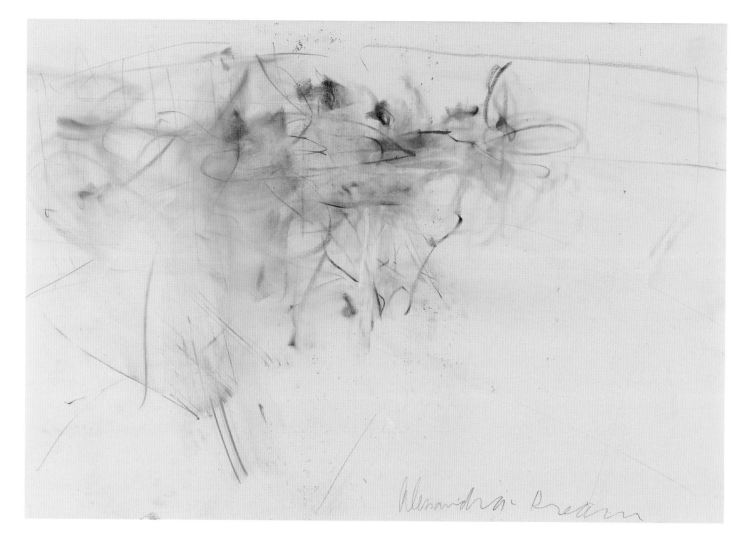

DREAM, 2002
AMERICAN BALLET THEATRE (FERRI)
PASTEL, CHARCOAL AND GRAPHITE ON PAPER
27 1/2" X 39 1/2"

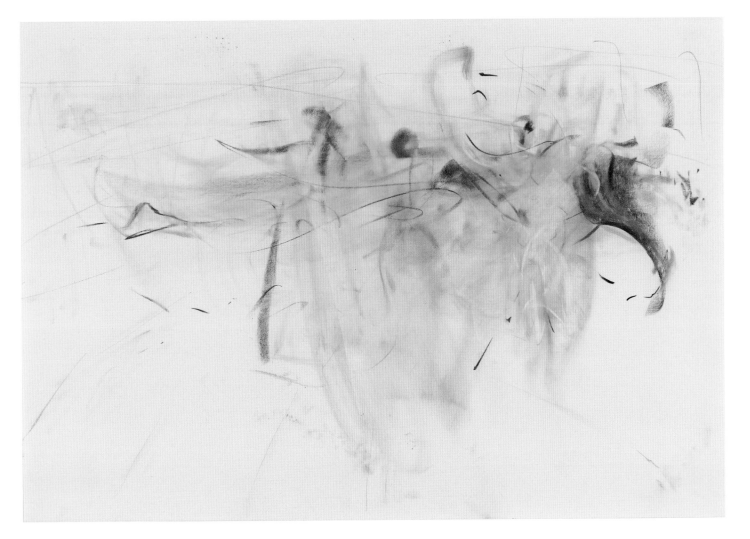

DREAM #7, 2002
AMERICAN BALLET THEATRE (FERRI)
PASTEL, CHARCOAL AND GRAPHITE ON PAPER
27 1/2" X 39 1/2"

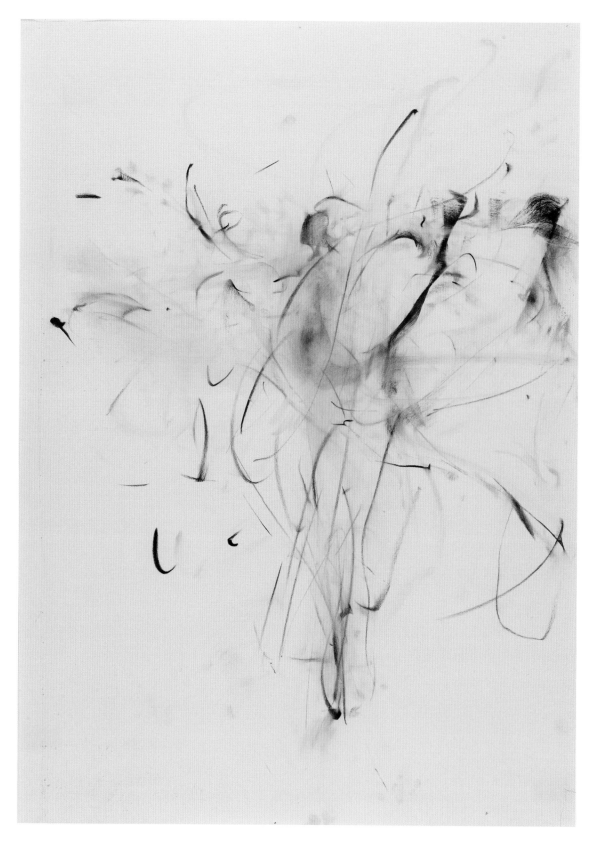

VARIATIONS #5, 2002
AMERICAN BALLET THEATRE (FERRI)
PASTEL AND CHARCOAL ON PAPER
39 1/2" X 27 1/2"
PRIVATE COLLECTION, NEW YORK

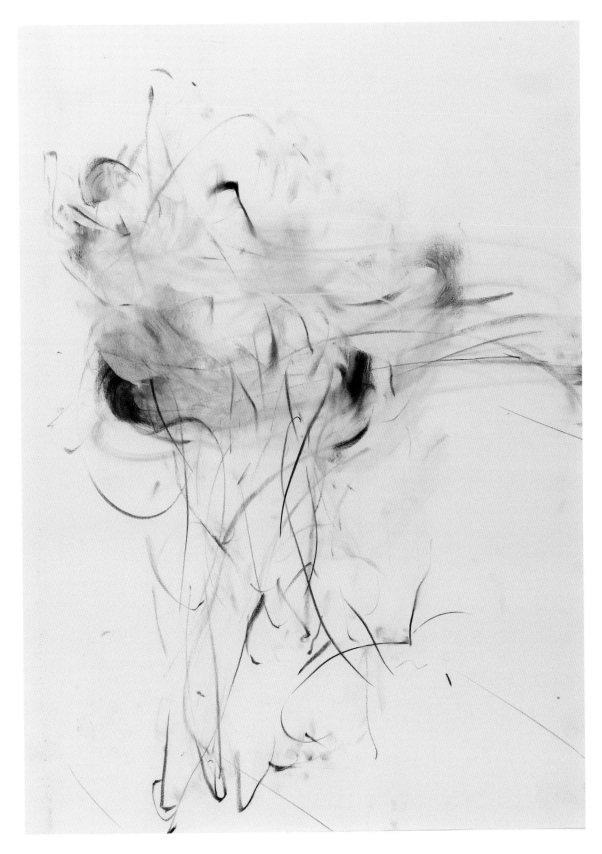

VARIATIONS #7, 2002
AMERICAN BALLET THEATRE (FERRI)
PASTEL, CHARCOAL AND GRAPHITE ON PAPER
39 1/2" X 27 1/2"

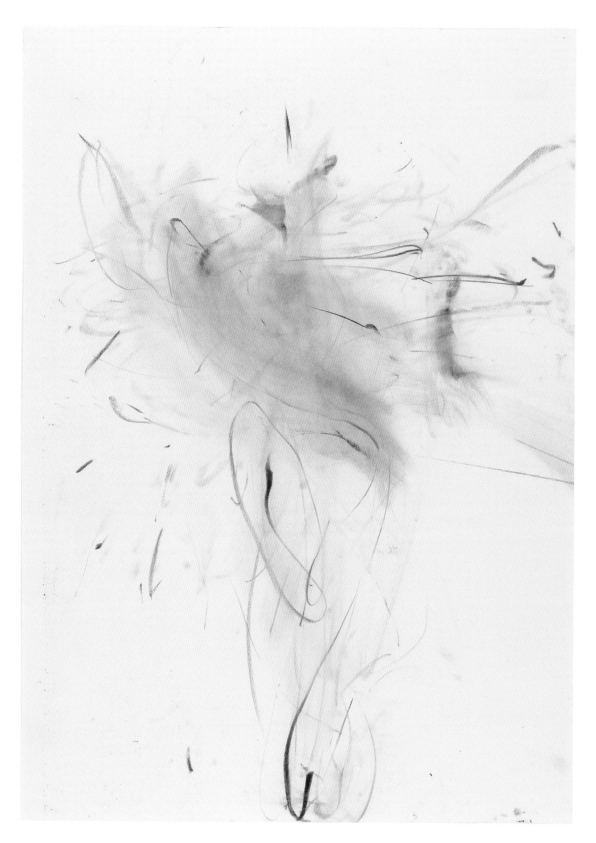

VARIATIONS #10, 2002
AMERICAN BALLET THEATRE (FERRI)
PASTEL AND CHARCOAL ON PAPER
39 1/2" X 27 1/2"

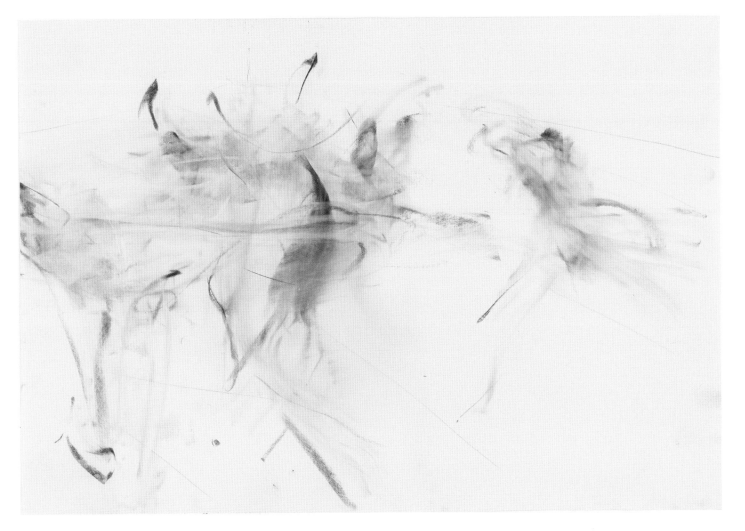

VARIATIONS #9, 2002
AMERICAN BALLET THEATRE (FERRI)
PASTEL, CHARCOAL AND GRAPHITE ON PAPER
27 1/2" X 39 1/2"

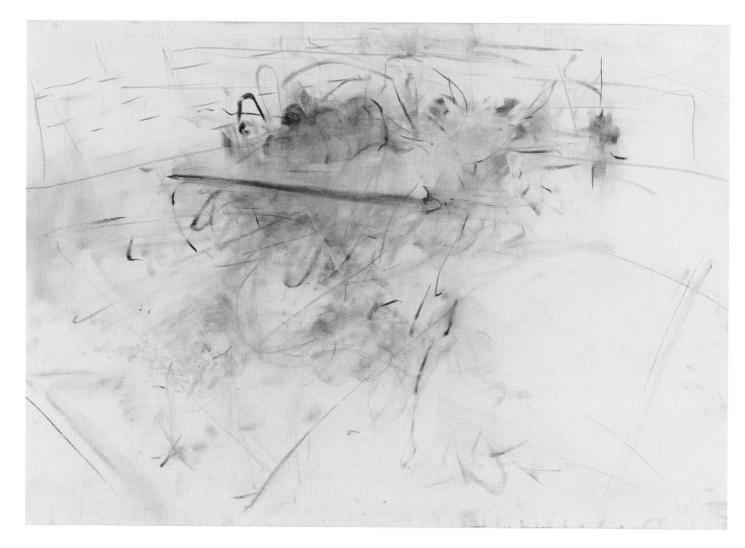

ONEGIN #1, 2002
AMERICAN BALLET THEATRE (FERRI/SAVELIEV)
PASTEL AND CHARCOAL ON PAPER
27 1/2" X 39 1/2"

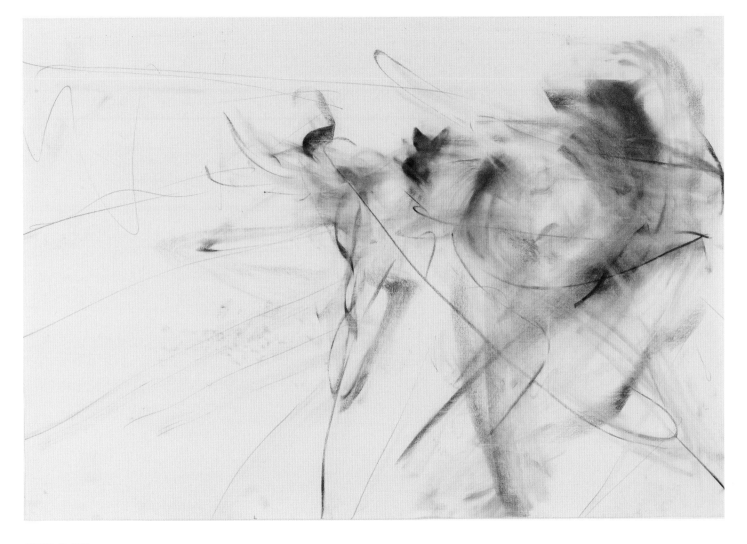

ONEGIN #3, 2002
AMERICAN BALLET THEATRE (FERRI/SAVELIEV)
PASTEL, CHARCOAL AND GRAPHITE ON PAPER
27 1/2" X 39 1/2"

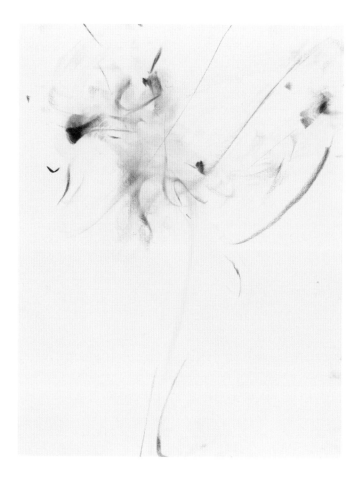

SYMPHONY IN C #6, 2002
AMERICAN BALLET THEATRE (JAFFE/MOLINA)
PASTEL AND CHARCOAL ON PAPER
24" X 18"

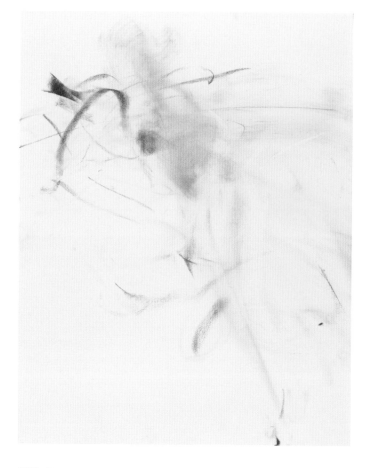

SYMPHONY IN C #13, 2002
AMERICAN BALLET THEATRE (JAFFE/MOLINA)
PASTEL AND CHARCOAL ON PAPER
24" X 18"

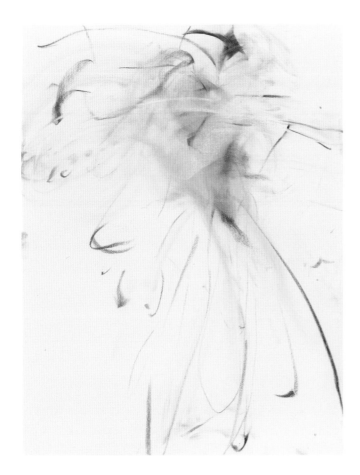

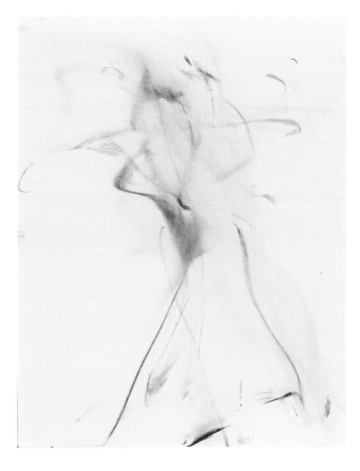

SYMPHONY IN C #11, 2002
AMERICAN BALLET THEATRE (JAFFE/MOLINA)
PASTEL AND CHARCOAL ON PAPER
24" X 18"

SYMPHONY IN C #7, 2002
AMERICAN BALLET THEATRE (JAFFE/MOLINA)
PASTEL AND CHARCOAL ON PAPER
24" X 18"

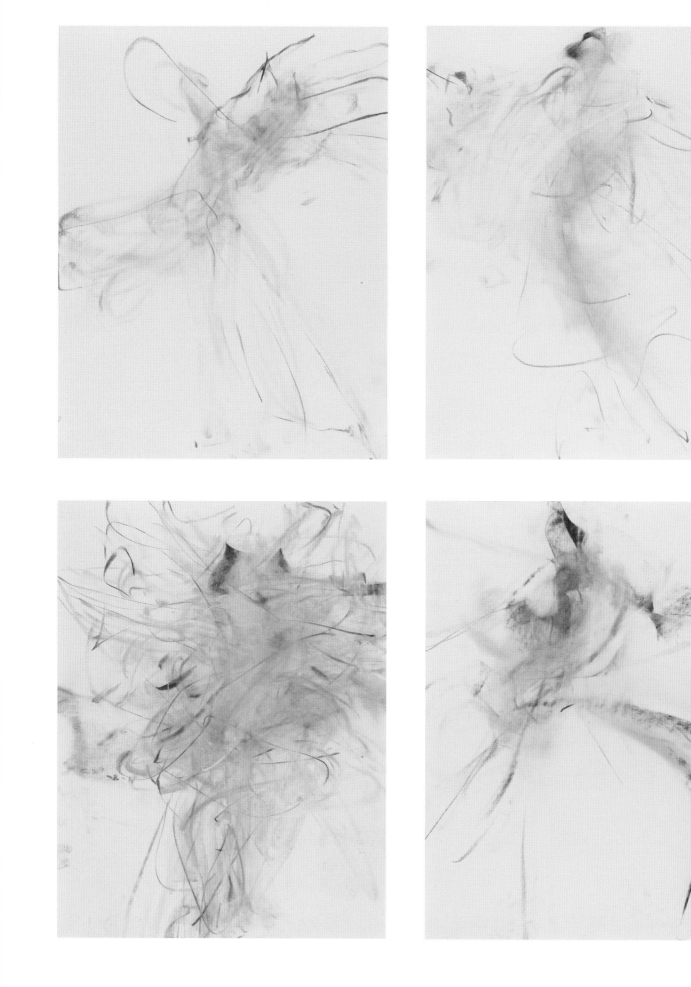

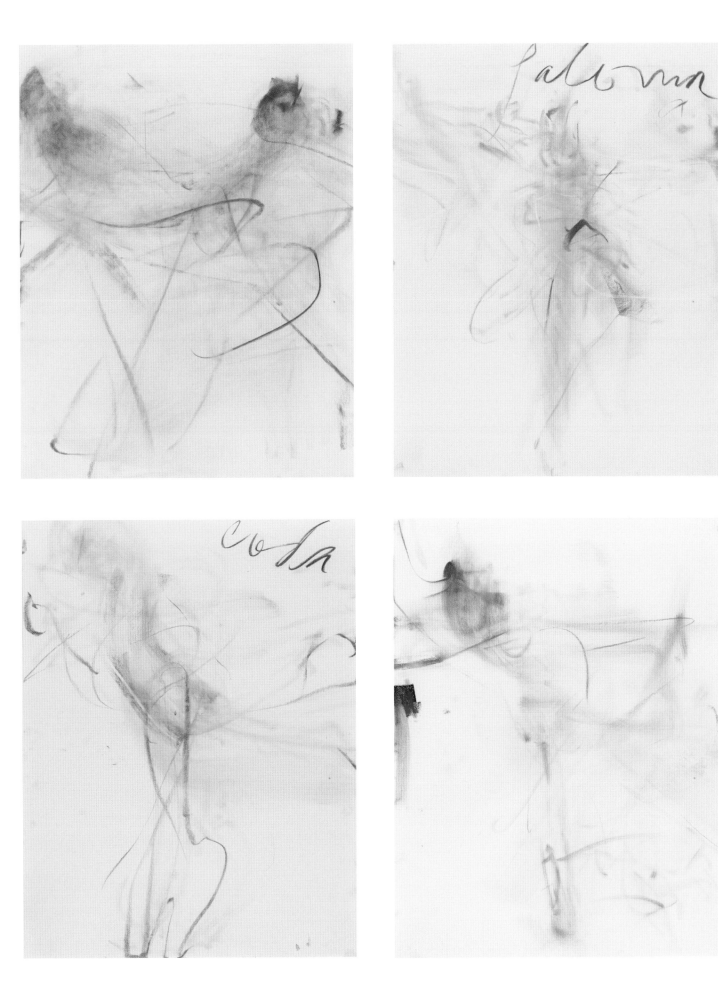

PAGE 34
(TOP LEFT TO LOWER RIGHT)

ISELLE #4, 2002
AMERICAN BALLET THEATRE (MCKERROW)
PASTEL AND CHARCOAL ON PAPER
24" X 18"

GISELLE #5, 2002
AMERICAN BALLET THEATRE (FERRI/BOCCA)
PASTEL AND CHARCOAL ON PAPER
24" X 18"

VARIATIONS #3, 2002
AMERICAN BALLET THEATRE
(MURPHY),
PASTEL, AND CHARCOAL ON PAPER
24" X 18"

ONEGIN #6, 2002
AMERICAN BALLET THEATRE (FERRI)
PASTEL AND CHARCOAL ON PAPER
24" X 18"

PAGE 35
(TOP LEFT TO LOWER RIGHT)

GISELLE #5, 2002
AMERICAN BALLET THEATRE (BELOTSERKOVSKY)
PASTEL, AND CHARCOAL ON PAPER
24" X 18"

VARIATIONS #1, 2002
AMERICAN BALLET THEATRE (HERRERA)
PASTEL AND CHARCOAL ON PAPER
24" X 18"

VARIATIONS #6, 2002
AMERICAN BALLET THEATRE (MURPHY)
PASTEL AND CHARCOAL ON PAPER,
24" X 18"

VARIATIONS #2, 2002
AMERICAN BALLET THEATRE (HERRERA)
PASTEL AND CHARCOAL ON PAPER
24" X 18"

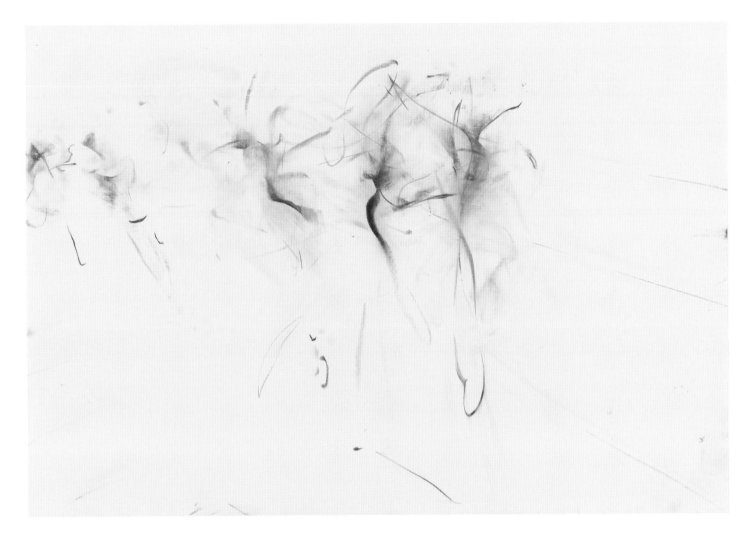

FILLE #6, 2002
AMERICAN BALLET THEATRE (TUTTLE)
PASTEL AND CHARCOAL ON PAPER
27 1/2" X 39 1/2"

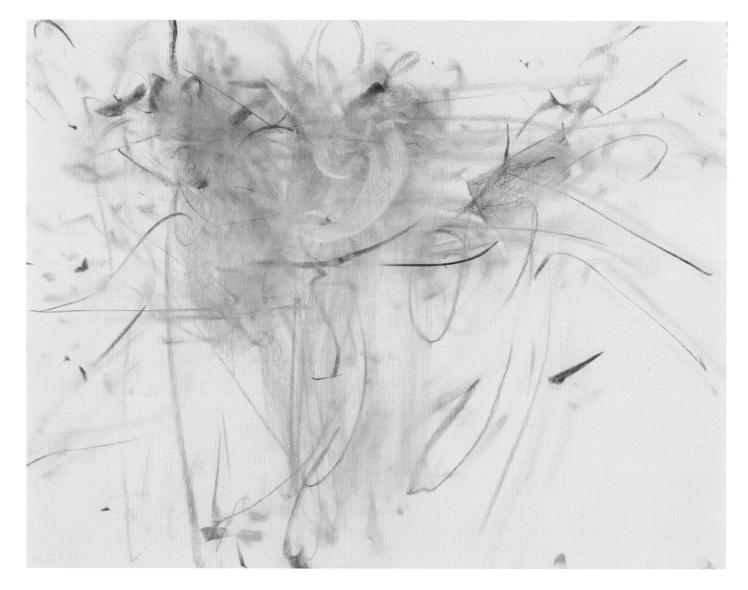

NUTCRACKER #1, 2002
AMERICAN BALLET THEATRE (KENT/CARRENO)
PASTEL AND CHARCOAL ON PAPER
18" X 24"

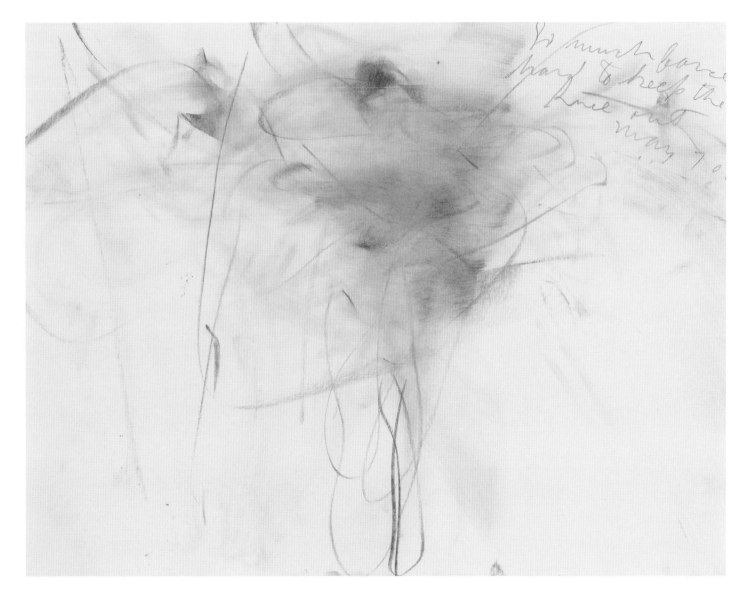

NUTCRACKER #4, 2002
AMERICAN BALLET THEATRE (KENT/CARRENO)
PASTEL, CHARCOAL AND GRAPHITE ON PAPER
18" X 24"

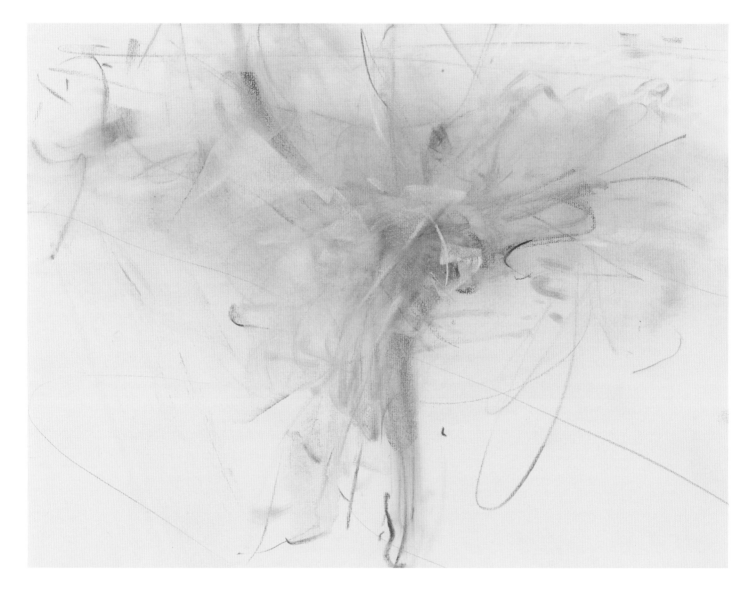

SB III #1, 2002
AMERICAN BALLET THEATRE (JAFFE/ACOSTA)
PASTEL, CHARCOAL AND GRAPHITE ON PAPER
18" X 24"

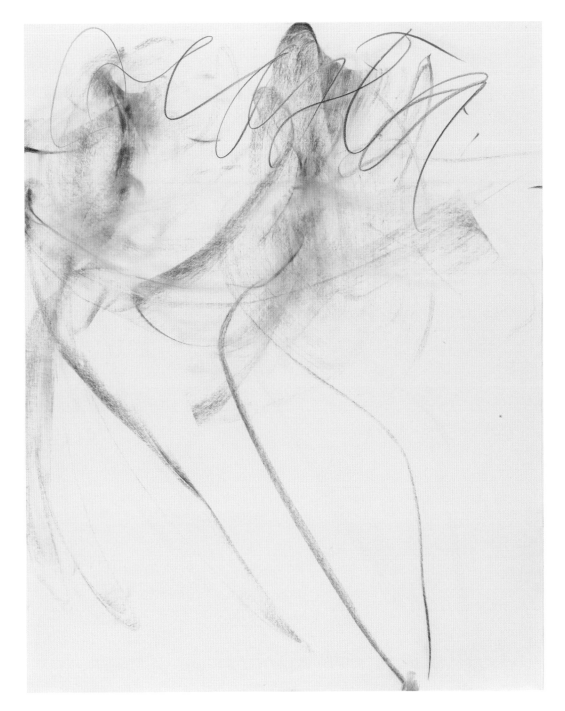

S.B. III #19, 2002
AMERICAN BALLET THEATRE (ACOSTA)
PASTEL, CHARCOAL AND GRAPHITE ON PAPER
24" X 18"

APPREHENDING THE FUGITIVE ART FORM

LINDA NUTTER PH.D., CMA

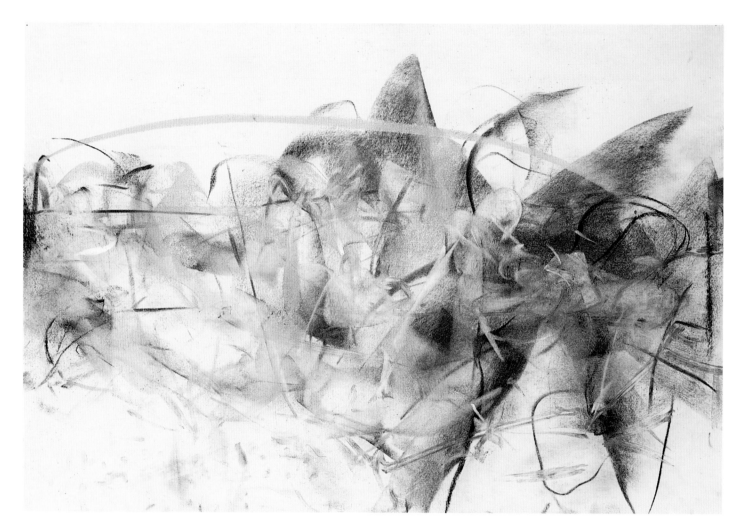

[FIG. 5]

NASCIMENTO # 15, 1994
PARSONS DANCE COMPANY
PASTEL AND CHARCOAL ON PAPER
27 1/2" X 39 1/2"
COLLECTION, GRAPHISCHE SAMMLUNG ALBERTINA, VIENNA

Before I stepped inside his studio for the first time, the only thing I knew about Terry Rosenberg was that he drew and painted dancers as they danced. As I entered his world and encountered two wall-sized paintings, I knew something else about him: that he understood the essence of dance and dancing in a clear and intimate way. As I stood beside him and looked through his drawings, I began to suspect that I was most probably in the presence of someone who possessed what I refer to as a "natural" phenomenological perspective. Within the first five minutes of interviewing him, I was sure of it. As time passed and I learned more about Rosenberg and his work, my analysis of what he does deepened yet again. Not only does he see dance through a phenomenological lens, but his practice and process of drawing dancers is actually a process of doing phenomenology.

Rosenberg draws dancers as they dance, but he does not merely draw dancers dancing. He draws dancers in the process of becoming the dance. His work communicates an intrinsic knowledge of the body–its manner of shaping itself to the environment, its spatial tensions, and its dynamic potential. Rosenberg has developed a mode of sensing/rendering the dance in a way that reflects its essential characteristics. It was natural that I should think immediately about phenomenology when I first viewed Rosenberg's work. As an analytical approach, "pure" phenomenology has long been allied with the desire to elucidate the nature and inherent structures of particular experiences, something that is clearly on Rosenberg's agenda.

As a movement analyst and ex-choreographer, I was startled at first by what I saw in Rosenberg's work. I had expected to see typical dance imagery, i.e., dancers doing things. Instead, I was confronted with the depiction of actual movement. Rosenberg doesn't draw dancers in the corporeal manner of his artistic ancestors. For a non-dancer, he has an uncanny ability to see inside the dance and capture the core constitutive elements of movement. Dance (not the dancer) explodes off the paper or canvas. Although I am sometimes aware of dancerly figures that advance out of the moving swirl before retreating back into the action of the drawing, they are not central to my experience of the work. I am captivated not by images of dancers doing things, but by the portrayal of a complex, dynamic, and symbolic life force.

Maxine Sheets-Johnstone was the first to write formally about phenomenology and dance. In her endeavor to describe how dance appears, she developed the term "forcetimespace," indicating that the dance, or the "form-in-the-making," appears as

the dancers' will evolves dynamically in ecstatic time and space. Writing years later, her colleague Sondra Horton Fraleigh writes, "When I close my eyes and try to picture a dance…is it forcetimespace that appears? How can forcetimespace appear? Forcetimespace is an abstraction until it is concretely manifested, until it is embodied. No, I do not see forcetimespace; I see the reality of dance in its corporealness–its lived concreteness. I cannot visualize a dance without visualizing a dancer. I can see embodied human motion, but I cannot see forcetimespace."

This example, drawn from the writing of two professional dance theorists, begs the question, "How exactly does dance appear?" What is it that we are looking at? Can we actually see an abstraction? One's ability to "see" is very personal. It is based upon many factors: our culture, our upbringing, our education, our current context, our embodied physicality, etc. Perhaps we should not say "ability to see." Perhaps it would be more correct to say "one's proclivities toward seeing." Perhaps the two dance writers are, perhaps, arguing semantics, but I do not believe this is true. I believe that when these two writers view a dance, they see very different things. Fraleigh sees dancers involved in action that can be symbolic. Sheets-Johnstone describes her experience of seeing the dancers, but of also actually seeing the symbolic abstraction created by the moving bodies. And it seems that Rosenberg does as well. The interesting thing about Rosenberg is not that he can see it this way, but that he can draw it. In his work, one clearly sees the unity of dancer and dance. One sees the dancer not as a still life, but as the center of a chaotic, soaring, complex weave of movement that reflects or explains something of life's most basic impulses. Operating below the surface and informing his work is a deep knowledge of what phenomenologists would call the "lived body."

Contrary to the Cartesian conception of a dualistic split between mind and body, the lived body concept does not involve a floating mind somehow affixed to a concrete and objective body. Those interested in the phenomenology of the body describe phenomena as they are experienced from within the subjective body. The lived body is experienced as a whole person, a seamless unity of mind and body. In this way, the body is not said to "house" the soul, and the soul is not said to "animate" the body. Experience is reflected in the unified mind/body, not simultaneously in a mind and a body. Rosenberg acknowledges his alliance with this perspective when he talks about the dancers he draws. What he is "ideally and definitely" trying to do is

hook into the essence of a person's existence at a particular moment in time. In drawing them, he attempts to capture a "combination of their dynamic, what they are muscularly, physically, structurally doing, their spirit and color, their attitude and how they do it…everything about how they appear to me. They bring up responses in me that form a kind of union with them…I know from the beginning that it's impossible to take the equivalent of a photographic click and get all that information…but I'm still trying to absolutely express what they do as clearly as I possibly can–to capture that living primal essence."

The union with the dancer that Rosenberg pursues speaks to one of dance's most important features. As a constructed illustration of embodied humanity, dance reminds us not only of our ability to express ourselves, but also of our ability to connect to and assimilate the expression of others. In doing so, we expand our boundaries and understanding of each other and, ultimately, the range and accuracy of our perception of meanings. For Rosenberg, the union that he usually feels with the dancers he draws is founded on a type of sympathy he experiences with them, a kinesthetic resonance that evolves as he clears the way to really be able to see and pay attention to them. For him, this sympathy is grounded in the knowledge that both he and the dancer exist in absolute flux, in a state of living and dying at the same time.

From the constantly unfolding evolution of the dance, Rosenberg snatches images, phrases, patterns and rhythms and weaves them together to create a semblance of the dance that is mysterious, oddly logical, and almost always reflective of his conception of time. Like the existentialists, he thinks of time in its ecstatic sense. In the lived-body experience of our internal consciousness, the past, present and future are a unity. In Sheets-Johnstone's words, "Man does not have a past since he is his past in the mode of not being it; he is always already present. He does not have a present, but is his present in the mode of not being fixed in the instant: his present is a flight which projects him into his future. Finally, he does not have a future since he is his future in the mode of not being it; his future is not yet, but is outlined upon the present out of which he moves toward the future as a goal. Man comprises temporality within himself, for he is such an ecstatic being: he is always at a distance from himself, always in flight." Rosenberg concentrates his energies on capturing this flight.

Dancers, their moods, and their bodies have always interested artists. Most art that takes dance as its subject portrays not movement or choreography, but dancers

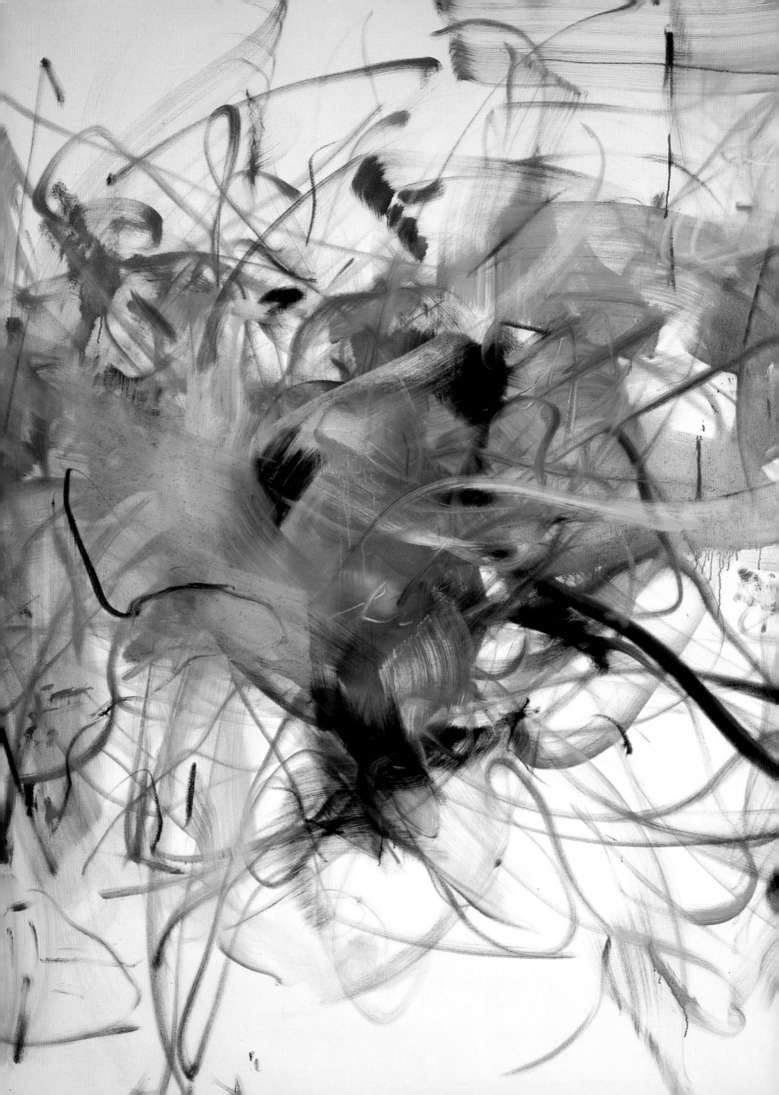

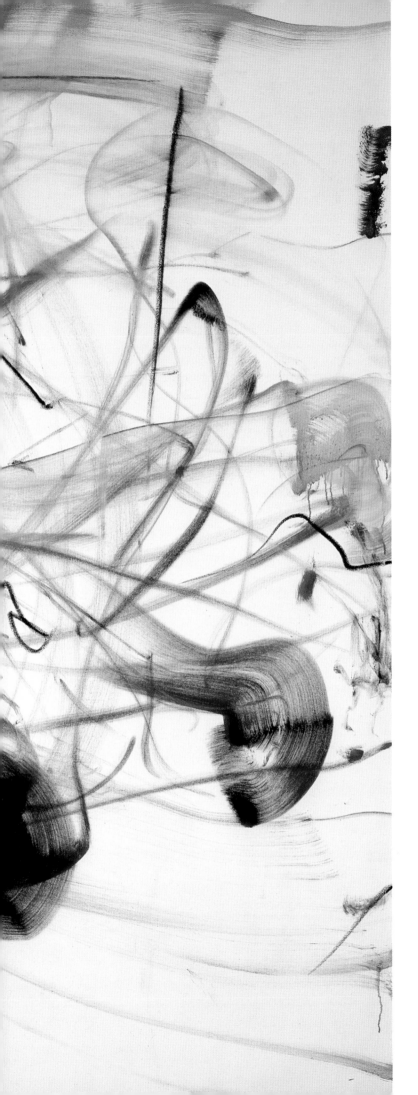

SONJA, 1997
OIL ON CANVAS
89" X 102 1/2"

and bodies. Dancers posing, dancers reclining, dancers leaping, etc. Claiming that this type of work depicts the movement or overall thrust of a dance is akin to claiming that publicity photos of famous actors capture the drama and action of the play they advertise. As representations of the art of "dance," we have drawings, paintings, photographs and sculptures that reveal the dancers' line, the dancers' costume, the play of light on the planes and curves of a torso or arm, the dancer contemplating the performance, the heft of a thigh, the bones of a foot, the theatrical and romantic nature of the working process, and the inner sanctum of the studio. We have great photographs that immortalize dancers, arresting them at some climactic moment of action–Baryshnikov in mid-air, Graham just seconds before an eloquent fall into the floor, Parsons or Ezralow diving head-first through the camera's frame, Humphrey poised breathlessly at the top of the arc. Like those captured by the more traditional art forms, the moments recorded on film are not dance or movement phrases. They are moments of action severed from the context of the dance, moments forever preserved, viewed, and interpreted within a vacuum. Traditionally, when dancers are drawn or photographed in motion, the resulting image only hints at what might have come before or after the liminal moment. The viewer interested in the "ongoingness" of the phrase must fill in the action in their mind's eye. Movement is indicated but not captured.

Although Rosenberg often says that what he draws are moments, in fact he capture phrases, and in many cases, much more. His work conveys the sensual cadence and pattern of the dance as it unfolds. The overall impression is not a chronicling of frozen moments, but of a layered, unified past, present and future.

Drawing movement is not an easy task. It involves the depiction of a vital dynamic through-line as it is lived and formed by dancers in the moment. Those who talk about the difficulty of the task often bandy about one of the most cherished dance clichés. Dance, they say, is ephemeral and fleeting, a fugitive art form, forever on the run from dissection, description and depiction. Viewed from this perspective, dance remains mysterious, impenetrable and impossible to capture. Rosenberg, apparently, doesn't see it that way. After twenty years of honing his techniques, he manages to penetrate the dance experience and do that impossible thing: he captures the essence of a truly great dance-watching experience–one in which the viewer suspends reflection and joins the dancer in a lived-body sense.

Rudolf Laban, who was arguably the most influential twentieth-century movement theorist, writes from a phenomenological sensibility. Rosenberg captures the elusive dynamic through-line that Laban called Effort. In his seminal work in identifying the salient features of a movement experience, Laban believed that it was the Effort qualities that gave a person's movement its character and animation. These Effort qualities are a result of the mover's inner attitude (conscious or unconscious) toward the motion factors of Weight, Space, Time and Flow. Within the Laban framework, these qualities are described and experienced from a lived-body perspective. Weight, for example, is delineated not simply as a matter of mass or weight, but as the experience of moving one's body in a way that either resists or fights the effects of gravity on the body, or yields to gravity and accepts it.

The motion factor of Space is observed and experienced not as a quantitative measurement of inches, feet and yards, but as a continuum in which the mover attends to the Space in a constricted, focused and withholding manner, or in a multi-focused, flexible, accepting manner. Time Effort does not focus on the deconstruction of chronological time into seconds or beats. It describes the mover's inner lived attitude toward the passage of time and is described on a continuum from urgent to a more luxurious and indulgent sensing of the passage of time. Flow Effort describes the progression of the movement as either Bound or Free.

The expressive body-mind produces many combinations of Effort qualities. The performance of two Effort components at once (such as Light Weight and Bound Flow) comprises an Effort State. Three components performed at once (such as Strong Weight, Quick Time and Free Flow) make an Effort Drive. In all, there are 72 different Effort combinations. Any short phrase of movement (either crafted dance movement or everyday movement) is a complicated network of changing effort qualities and combinations. Humans have the capacity to comprehend the nature of the qualities and to recognize the rhythms and structures of each other's sequences.

Rosenberg has a real understanding of Effort. "By trying to draw out these built-up gestures over time, you get this exposure to someone's internal desire or their own motivation. You can read it in the dynamics, the velocity of the brush stroke, how one thing crosses over another, and how you see it spatially in pictorial space." Although he often says that he "draws what he sees" and that he is "simply trying to draw the movement," it would probably be more accurate to say that he draws what

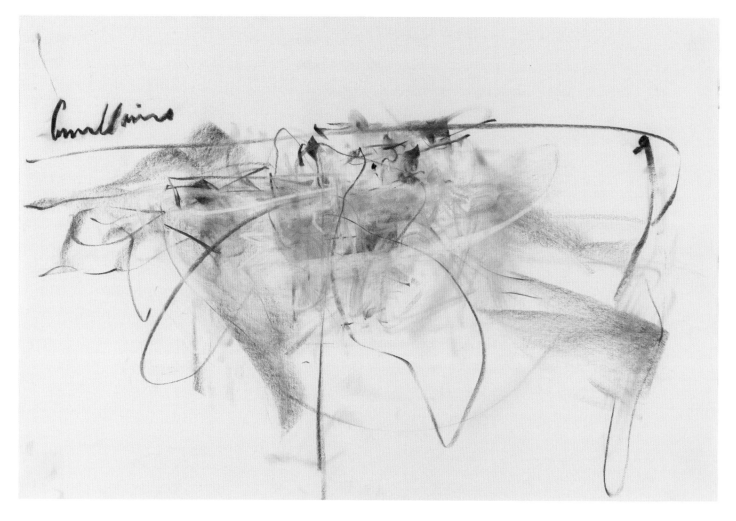

FOURSOME #4, 2002
MARK MORRIS DANCE GROUP
PASTEL AND CHARCOAL ON PAPER
27 1/2" X 39 1/2"

he feels or experiences. Embodied in his sensitive renderings is not only the dancer(s) appearing before him, but Rosenberg himself. His physical ability to embody and reflect the dancers' Effort life is what sets him apart from others who use dance and dancers as their subject. He is able to capture the layered rhythms of the movement because he is able to open his body to receive the sense data. What we see on his canvas is not an interpretation of the movement as seen through his eyes, but a kind of channeling of the dancers' energies through his own body, out through his hand, and into the work.

Many of us have what could be referred to as our "Effort repertoire." As we age, we lose our child-like ability to respond openly and appropriately to stimuli and begin to cultivate a set of responses that somehow defines us. These responses are always both emotional/mental and physical. To draw a very broad and generalized example, we can imagine a hyper-stimulated type of person who is mostly expressive/responsive through combinations of Quick Time, Direct Space, and Free Flow. (Although the other Effort elements may appear briefly in transition or recuperation.) Another person may define him or herself as more "easygoing" and that could be reflected in a persona that is loaded on the Effort front with movement that revolves around Sustained Time, Free Flow, and Indirect Space combinations. Although change is always available to us through conscious work in modalities ranging from psychotherapy to bodywork and yoga, most of us believe that "we are who we are" and accept the physical and emotional restrictions of our choice. With the passage of time, it becomes more and more difficult to step outside of our repertoire and expose ourselves to a different manner of feeling/responding/acting. One would imagine, therefore, that when someone such as Rosenberg viewed dance, what would impress itself on him and then be translated to the canvas would be the qualities with which he himself was most conversant. This does not seem to be the case. A viewing of his works shows a wide range of Effort sensitivity. Within the lines, smudges, and patches of color there exists a deep well of potentiality: gentle and delicate meandering, slow persistent perseverance, measured cautious withholding, forceful energetic driven pounding—the interpretive possibilities are endless. Of course, all of this gets greatly complicated when one tries to draw more than one dancer at a time.

If it is nearly impossible to capture just one dancer in flight, how then would one draw a group? Take Nascimento #15 { FIG. 5 }, a charcoal and pastel of the Parsons

Dance Company (1994). As in many of Rosenberg's drawings, there is a constant question in my mind as to whether I am looking at one dancer drawn through time, or at a number of dancers drawn nearly simultaneously. Does it matter? The action seems to move from upstage right to downstage left in a gentle slashing, whirling and spiraling manner. The phrase seems to reach its dynamic climax as a lone figure appears to emerge out of the group and revolve into a one-legged balancing point facing down-stage right. At the same time, ghostly figures seem to lift the mover back around and into the evolving group, ready, perhaps, to begin another circuit. Although I am unfamiliar with this dance, the drawing speaks to me of cycles and of an incessant ambivalence concerning the repetition of patterns–both good and bad. The drawing, of course, is completely abstract and each time I view it, my perspective shifts slightly.

So how does Rosenberg achieve all this? It might be tempting to answer this question through a formal or syntactical analysis of the drawings and paintings themselves. This would involve analyzing his use of the two-dimensional space, light, line, shape, brushstrokes, color palette, surface, etc. Rosenberg could be videotaped and a movement analyst could examine the correlation of his movements to those of the dancers before him. Alternatively, the analyst could look at the tools that Rosenberg has developed to aid his drawing process, the challenge of making the tools work as an extension of his body, or the effect that they have on his touch. I suspect, however, that these analyses, while fruitful in their own right, would not really get to the heart of why Rosenberg can draw dance in the way he does. His work succeeds in conveying the subtle and ever-changing spatial, dynamic and humanistic rhythms not only by what he is able to do with charcoal or paint, but by how he is able to hold himself open to actually see and experience the movement event.

As is true of all the arts, dance can never be fully defined or analyzed by one aesthetic perspective or point of view. Viewers experience and appreciate dance as a multiplicity of levels of significance. They see and value different aspects of the total dance phenomenon. These aspects may include formal or syntactical properties such as structure or technique; the symbolic transformation of human feelings into movement; the experience of dance as the lived movement-in-time-and-space; and the embodiment of a sense of the historical or cultural epoch in which the dance work was created. Analytical traditions and systems within the field of aesthetics address the various levels of artistic significance. (As is typical of human nature, practitioners of a

particular method usually feel justified in claiming that theirs is the one true way to approach a work of art.) The method that examines lived movement-in-time-and-space is phenomenology. Although he claims no formal training in the method, either in general or as it is applied to dance, Rosenberg's work and working process clearly exemplify the phenomenological method. Understanding phenomenology sheds light on how Rosenberg manages to get inside the dance to the degree that he does.

Phenomenology is the term used by philosopher Edmund Husserl (1859-1938) to describe a method of inquiry used to produce in-depth, descriptive accounts of all forms of consciousness and immediate experience. Husserl was originally interested in developing a method by which "phenomena" could be examined and scrutinized to reveal their "essential and necessary" characteristics. This examination would then yield information that was scientifically verifiable. As he conceived it, a phenomenological examination would focus on experience as it occurred, not on theories or hypotheses about the experience. Husserl sought a perfect or "apodictic" knowledge about the phenomena being examined. His goal was to provide science and philosophy with a method by which the natural sciences, religion, the social sciences, art, virtually anything, could be examined. Through that examination, a kind of truth about the phenomena would be revealed.

Rosenberg, too, seems to be in search of the "truth" behind each dance event he experiences. He describes his process as a way of drawing out the essence of the dance and getting at an intimate nature—human nature. Although he is not a professional phenomenologist or dance theorist, Rosenberg contributes to both fields through his drawings, paintings, and thoughtful interviews concerning his process. By casting Rosenberg in the role of dance researcher or theorist, we can begin to examine his affinity with the phenomenological method. We can imagine him not as an artist who creates art with dance as its subject, but as a writer who uses the phenomenological method to describe the dance as it unfolds before him in present time.

In a 2001 interview with Richard Kendall, Rosenberg discusses the challenge of readying himself to receive what the dancers before him have to present. He says, "When I actually do the work I really just try to open myself up to that which I'm drawing, and try to put everything else that I know or I've learned or heard behind me. When I'm drawing movement I have to leave everything behind to be able to keep up with that kind of activity…it presents a lot of challenges for me to leave my own personal

baggage behind. What I think my work should look like or mean, or what people are going to think, or what I think…I am simply trying to draw the movement. And that is a wildly complex thing to do. So it made me realize that all those thoughts that come into my head clearly must be left behind on this trip."

Although Husserl himself did not actually outline the way one was to go about performing a phenomenological analysis, he discussed and delineated many complex and technical principles. One of the first principles he deemed necessary so that "direct observation" of the phenomena could occur was known as "bracketing." This involves the "bracketing out" or "suspension" of any beliefs one has in specific theories, concepts, or symbols. This is what Rosenberg refers to when he speaks of "leaving his personal baggage behind." As he is working, Rosenberg attempts to bracket out (essentially ignore) anything he conceptually knows about choreography, dance, dancers, dance technique, dance theory, dance symbolism, dance mythology, etc. His goal is to allow the present dance to imprint upon him in as pure a way as possible. In a later interview, Rosenberg talked to me about trying to rid the process of his subjective control over the dance. This illustrates another major concern of Husserl's pure phenomenology.

In his work, Husserl believed he was reacting against what he viewed as rampant "subjectivity" in the research methods of his day. This subjective perspective colored the information that could be gathered about the world. His motto became "back to the things themselves." By suspending belief in theories, concepts and symbols in favor of what is directly observable, he strove for a kind of perfect observation. In his search for this pure empiricism based on the immediate perception of "things," he hoped to provide systematic descriptions of objects, free from the biased, subjective interpretations of the human viewer.

An imaginary example may help illustrate how this bracketing might occur within Rosenberg's actual process. One of the companies Rosenberg has drawn is the Mark Jarecke Dance group. As he readies himself and begins to draw, Rosenberg tries to suspend anything he knows about the choreographer, his group, or the individual dancers. If he knows that Jarecke is more interested in visual or spatial criteria and less interested in kinesthetic sensation or narrative, he suspends that in favor of what he actually experiences. He will not, for example, try to render the spatial patterning while ignoring emotive content…unless that is what he felt was truly

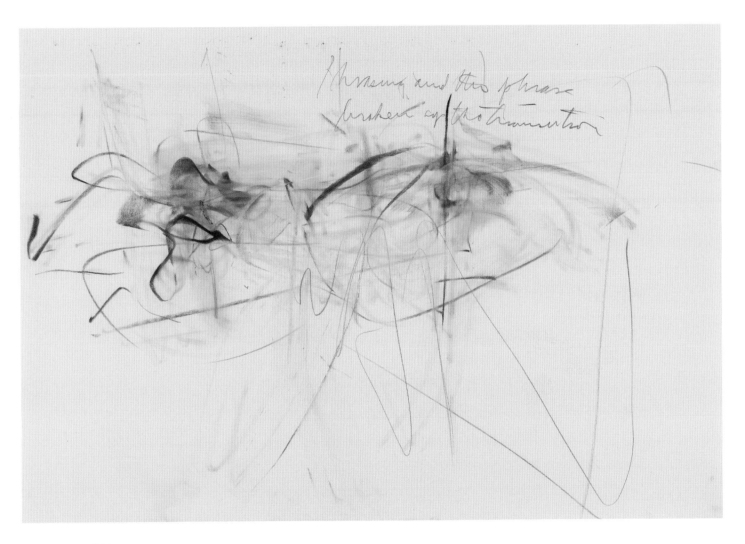

AUTO PUBLIK #7, 2000
MARK JARECKE
PASTEL, CHARCOAL AND GRAPHITE ON PAPER
27 1/2"X 39 1/2"

present in the movement. Anything that the dancers might verbally reveal to him about their current physical condition, anything that Jarecke might have told him about the work he is about to see, and anything he might imagine about costumes, music or sets that are not part of the present session will be bracketed. Instead, Rosenberg tries to render what is immediately observable–what he can actually see and kinesthetically experience.

In addition to suspending what he knows about dance, he also attempts to suspend what he knows about his own art. In discussing this, he says, "Part of this whole practice of drawing dancers in the moment is for me to get over my own preconceptions about what painting or drawing should be. It demands that I surrender my own ideas about how I draw lines, how I make shapes, how I make background, foreground, whatever…things start to blur when I'm really connected to the dance. I can sit and watch myself draw on video and I can see when I lose focus–when I get too interested in what is happening on paper and I don't stay with the dancer. I can see it instantly. I can see myself pull out and go back into the formal drawing process. Intense focus is the best-case scenario–it yields the best and most interesting results. It is here that the process really begins to open up." He also tries to suspend all judgment about the work, while working, and all comparisons to other work. He must do this in terms of both the choreography and the drawing. In phenomenology, this thinking/experiencing process is called "pre-reflective." One tries to stay with the experience and not be pulled into "reflecting" about other issues.

The phenomenological reduction has at least two stages, the Transcendental Reduction and the Eidetic Reduction. Bracketing occurs in the first stage. This Transcendental Reduction (also termed the epoche) requires a change from ordinary perceiving to phenomenological perceiving. Ordinary perceiving is characterized by the "natural attitude." This natural attitude is the sum total of our preconceptions and predispositions toward something–the way we "expect" something to be or appear. What is needed is the suspension of the natural attitude; a move from perceiving something to examining how we perceive something. Suspension of the natural attitude is founded on the transcendental reduction.

The transcendental reduction is marked by a turning inward toward consciousness. Humans have the unique power to transcend our own consciousness and examine it. In thinking about how we think, we can engage the process of conscious activity. By

turning inside and thinking about how one is thinking about something, Husserl felt that it was possible to suspend all preconceived views, ideas and assumptions about what an object might mean and instead concentrate on how the "something" is appearing before us. One can, in effect, choose to transcend how one usually thinks about something and open oneself to a more fully multi-dimensional experience. This suspension of the natural attitude allows one to more clearly focus on what is actually appearing to consciousness.

If Rosenberg were a dance analyst/writer, stage one of the phenomenological reduction would take the form of quick, spontaneous, fearless writing about the dance experience. It would be a kind of stream-of-consciousness response that might also take the form of short poetry-like utterances. As noted, the analyst suspends or brackets out personal preferences, syntactical observations, and all thought about referential meaning, historical significance, or comparative analysis. The goal is to be fully present in the dance experience.

Stage two of the phenomenological reduction, the Eidetic Reduction, involves moving toward the object's essence (or "Eidos") so that essential structures and relationships are clarified. The purpose of this step is to discover the "essences" of the thing in question—Husserl believed that if one could extrapolate these essential and defining structures from the experience, one could gain a kind of truth or universal knowledge of it. During the Eidetic Reduction, the analyst examines the information acquired in the first step and looks for themes or motifs that may evolve or become apparent. Again, if Rosenberg were a dance writer, he would utilize these themes to construct an analysis of the dance that would, theoretically, convey a kind of "truth" about the work.

But Rosenberg is not technically a dance writer or analyst. His form requires a more immediate type of presentation. The remarkable thing about Rosenberg is that he seems to be able to perform both steps of the reduction simultaneously, in the moment, while creating. He doesn't give himself the luxury of time and reflection. While he could choose to videotape the dance and work from multiple viewings, he chooses instead to render the dance as it is happening. As if this in itself isn't enough, he also challenges himself to render those things that are essential and defining to the dance. Although I know that Rosenberg experiences the dances he draws from a distance, as an "outsider" if you will, his drawings often trick me into believing that he

drew them as he himself danced the movement. There is an understanding of the dancers' sense of lived space that is clearly present in the work. The spatial scale of the drawing is somehow always in sync with the dynamic expression. There is a body logic at work and it draws the viewer's attention simultaneously inward toward their own body and outward toward connecting with other moving bodies. In attempting to elucidate his union with the dancers, to find the basis of some kind of primary relationship he has with them, he manages to nudge the audience of his paintings toward the same eventual goal.

It should be noted here that later students of the phenomenological tradition debate whether Husserl's transcendental epoche and reduction is even possible. We do have conceptions, attitudes and assumptions which color understanding. Philosophers such as Hans-Georg Gadamer and Martin Heidegger believed that attempting to suspend one's pre-understandings was, in essence, an attempt to suspend what is essentially one's own being-in-the-world. According to Heidegger, "there is no pure, external vantage point to which we can retreat in order to get a disinterested, presuppositionless angle on things." In essence, any act of interpretation is influenced by one's own pre-understandings and historical relativism. Still, at its best the phenomenological reduction is an effort to remove bias and preconceptions from consciousness that unduly affect our ability to experience something. It aims to describe through some direct route, not to analyze or theorize (at least not in the beginning), but first to describe the immediate contents of consciousness. To quote Sheets-Johnstone again, "In attempting to follow the phenomenological method, one sometimes discovers, within the total structure of the thing presented, new insight into the nature of its appearance." In the general scheme of things, it may not matter that pure phenomenology did not turn out to be the verifiable "science" that Husserl wished to outline. In my experience, even the slightest attempt to approach phenomena in this way yields fruitful results. This getting "back to the things themselves," getting to the thing about which knowledge speaks, is the primary goal. This is what Rosenberg is getting at. Not a rendering of what we know about bodies and relationships and how they are constituted in our society, but a rendering of the moment itself, which in turn teaches us about bodies and relationships and how they are constituted in our society.

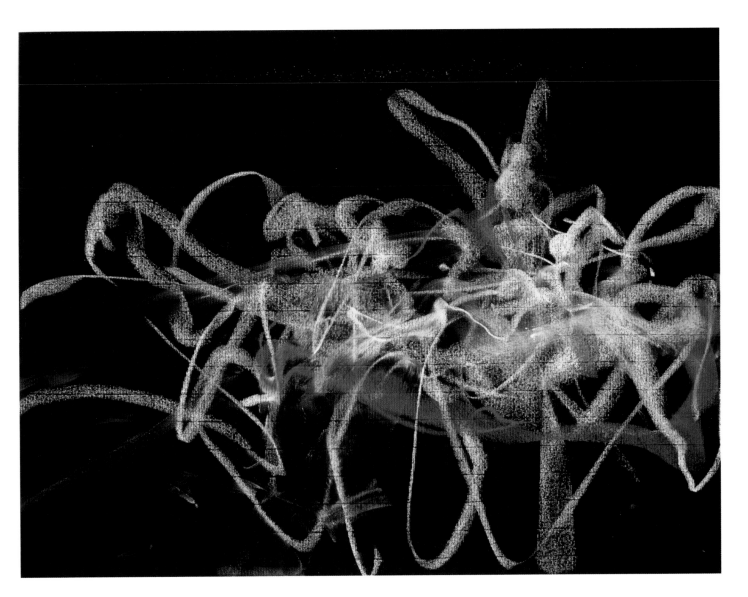

BALLAD #24, 1999
BILL T. JONES / ARNIE ZANE DANCE COMPANY
PASTEL ON PAPER
19 1/2" X 25 1/2"

In the current dance literature, there are very few phenomenological accounts of actual dances. Given his skill at performing the phenomenological reduction, if Rosenberg were a dance writer, he would be performing a much-needed service. Thankfully though, he is not an ivory tower academic. What he creates serves an audience of much wider appeal. He is not interested in becoming the scribe of western concert dance forms. What he wants to make are provocative and interesting images that spring from a historically new point of view. I recently asked Rosenberg if his way of seeing evolved out of his interest in dance, or if his interest in viewing/drawing dance came about through his way of seeing. He responded that his initial interest in this arena was in developing his ability to see and capture imagery as it was created in the present. Since he always believed that he could learn a lot from what he called "body-smart" movers, dance was an obvious choice.

Linda Nutter Ph.D., CMA trained as a dancer and choreographer before receiving her Ph.D. from New York University in Aesthetics and Dance Analysis. She is a Certified Laban Movement Analyst and teaches on the faculty of the Laban-Bartenieff Institute of Movement Studies in New York City.

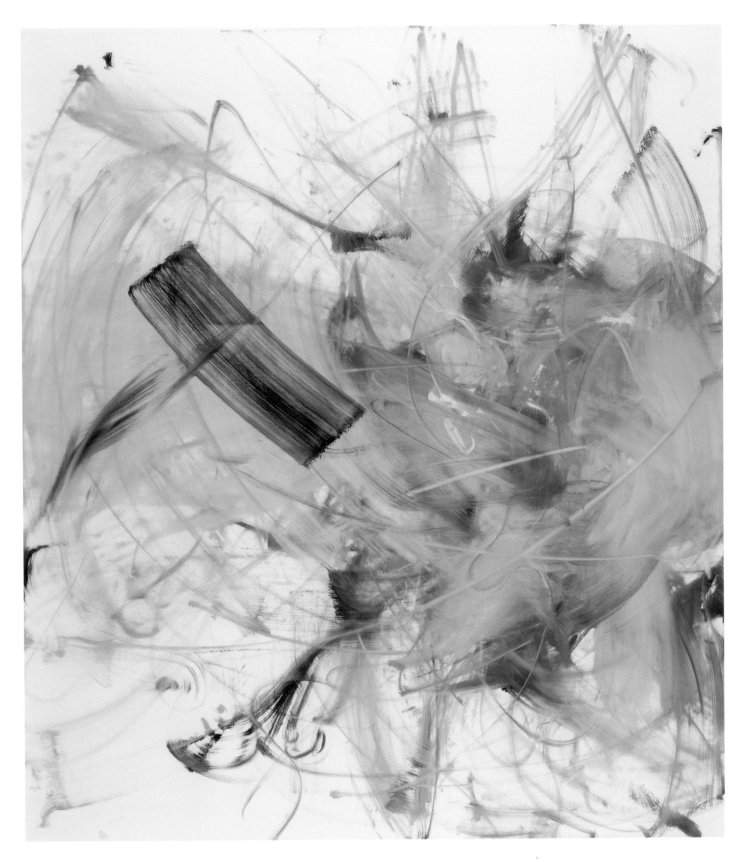

JARECKE, 2001
OIL ON LINEN
87 3/4" X 76"

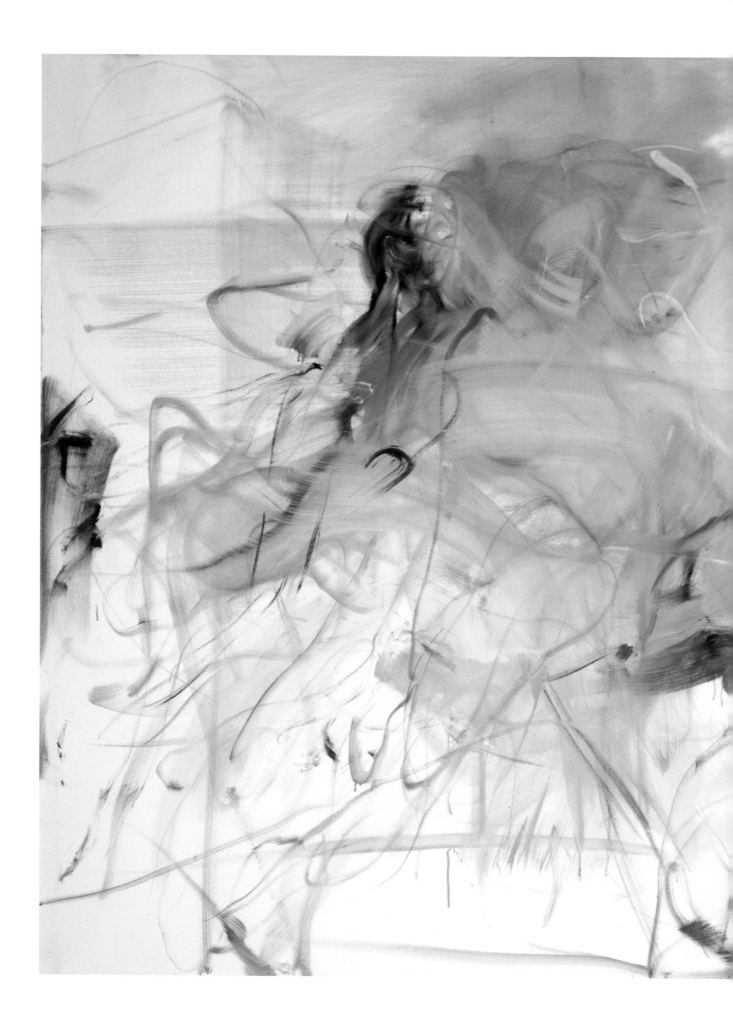

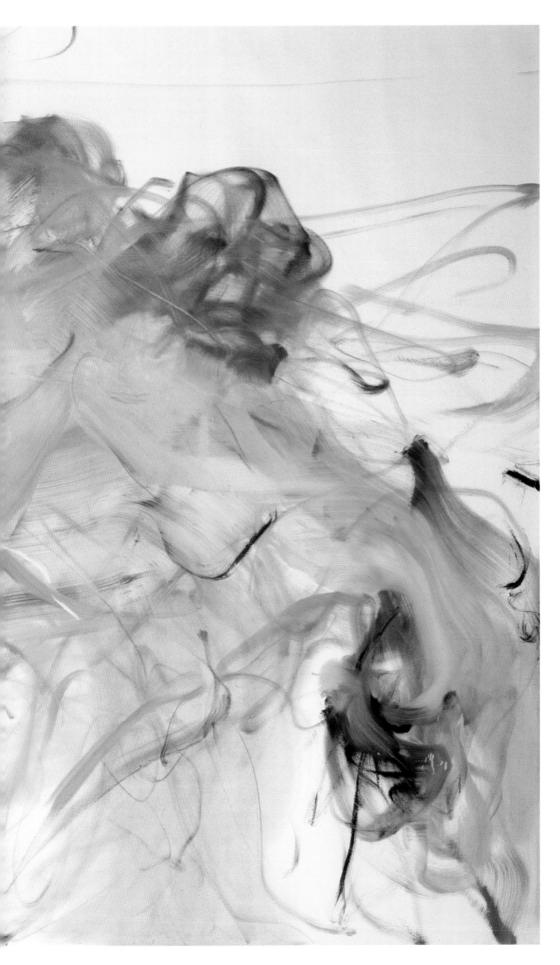

SONJA, 1998
OIL ON CANVAS
78" X 110"

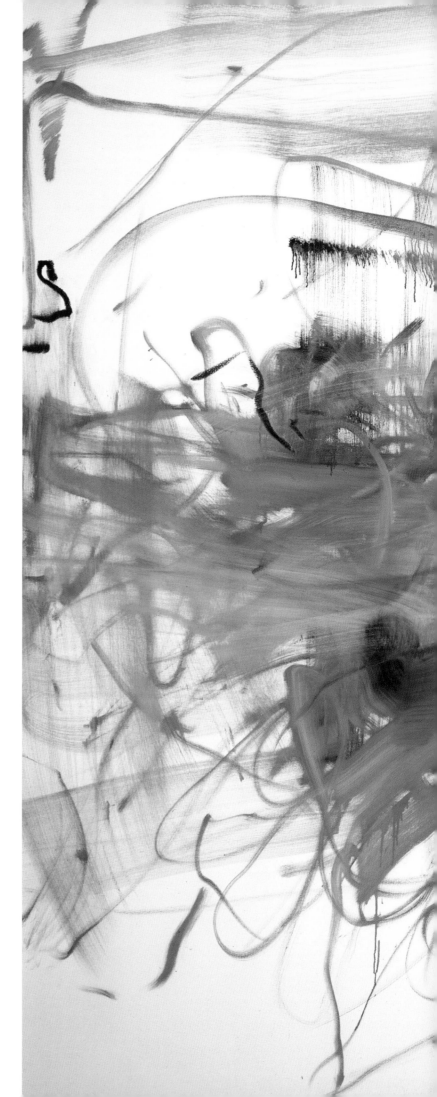

SONJA, 1997
OIL ON CANVAS
89" X 102 1/2"

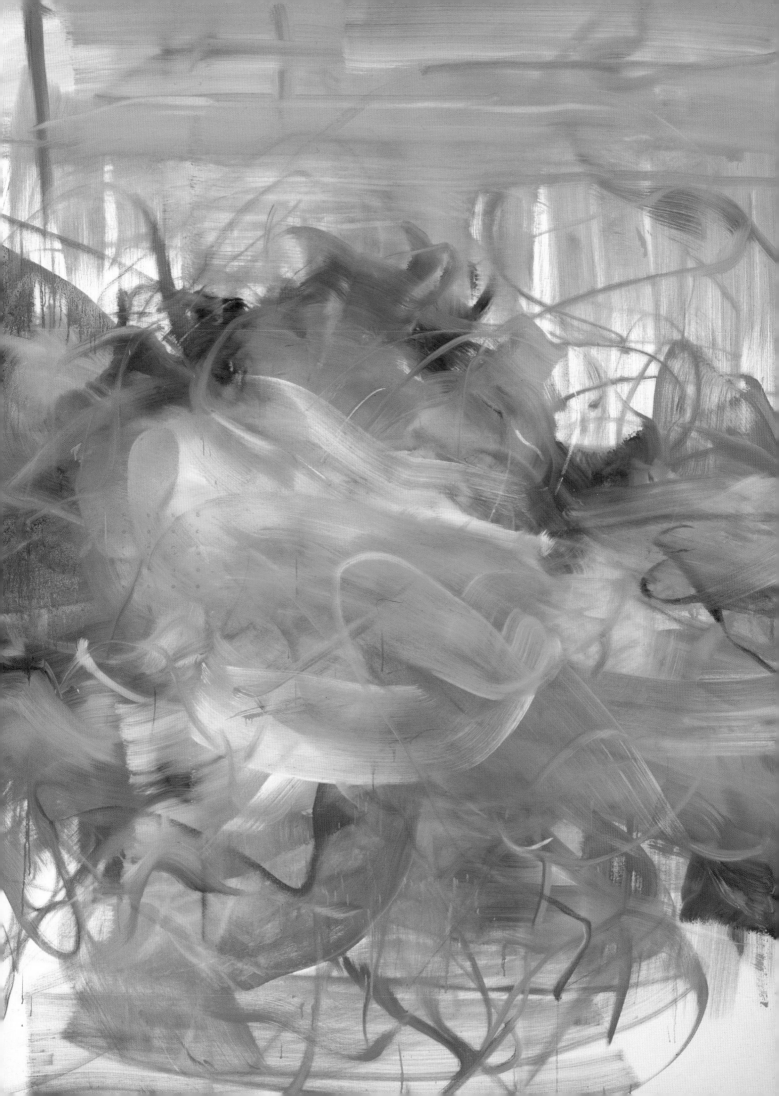

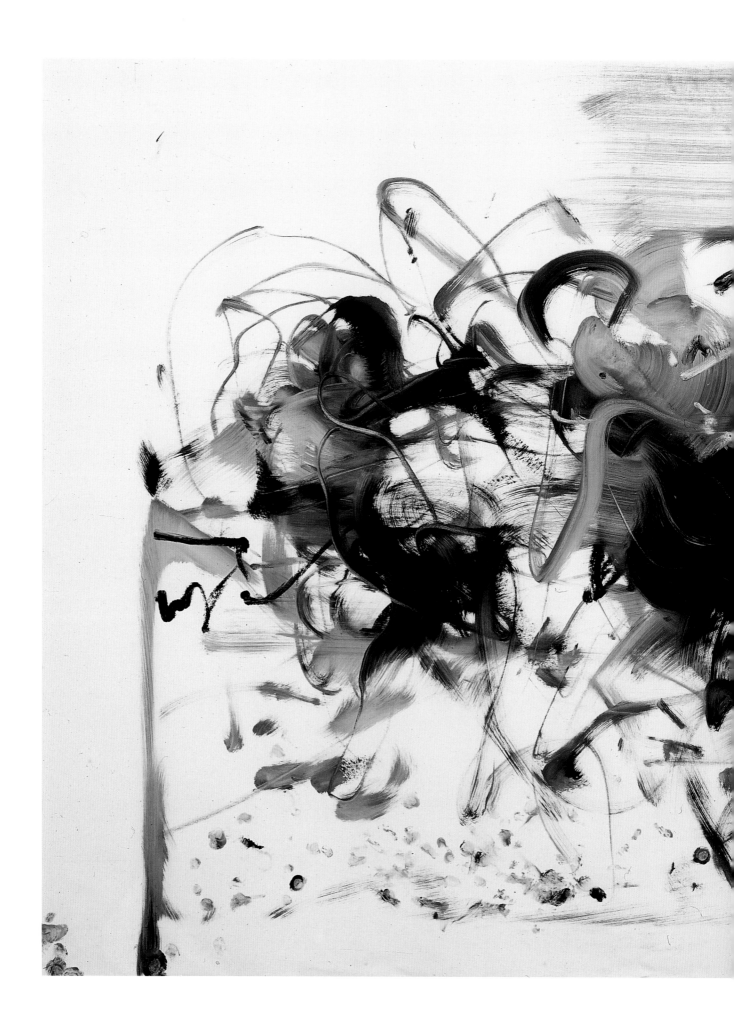

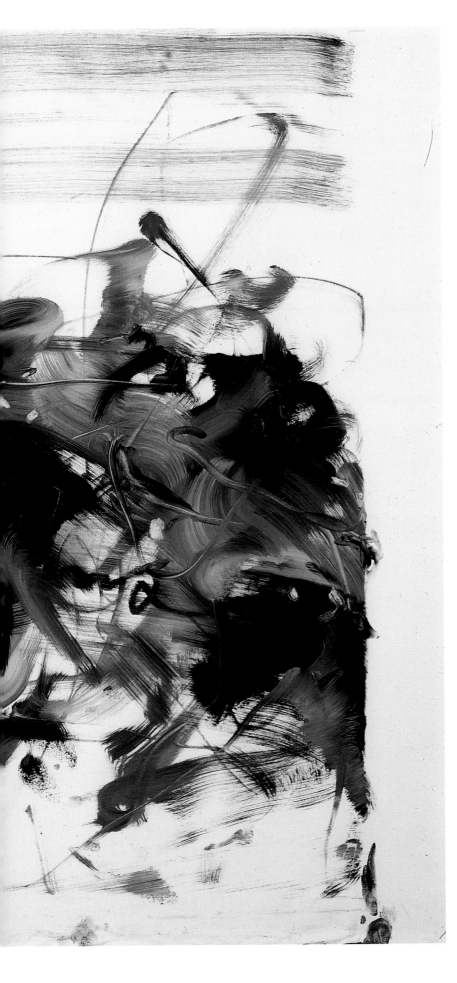

AMY, 1997
OIL ON CANVAS
48' X 60"
PRIVATE COLLECTION, NEW YORK

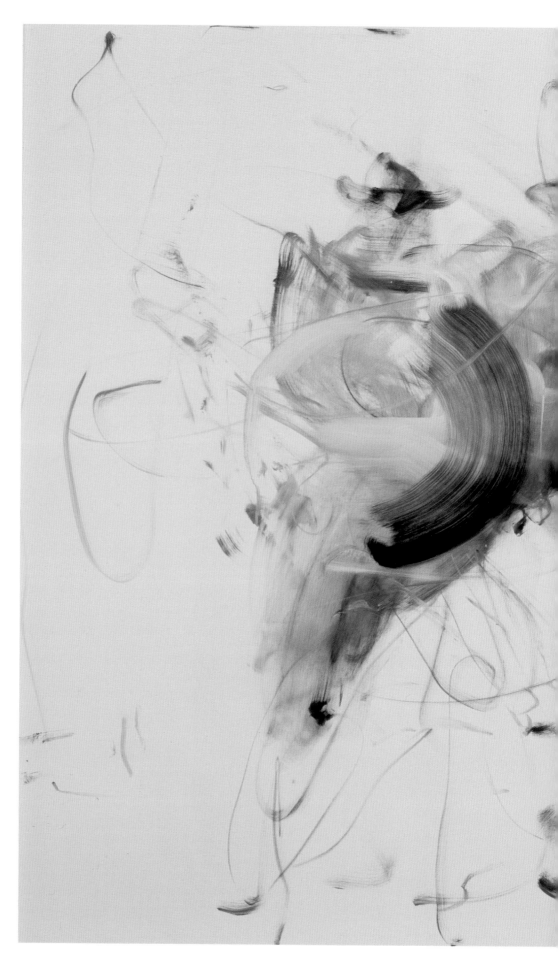

SONJA, 1997
OIL ON LINEN
78" X 110"

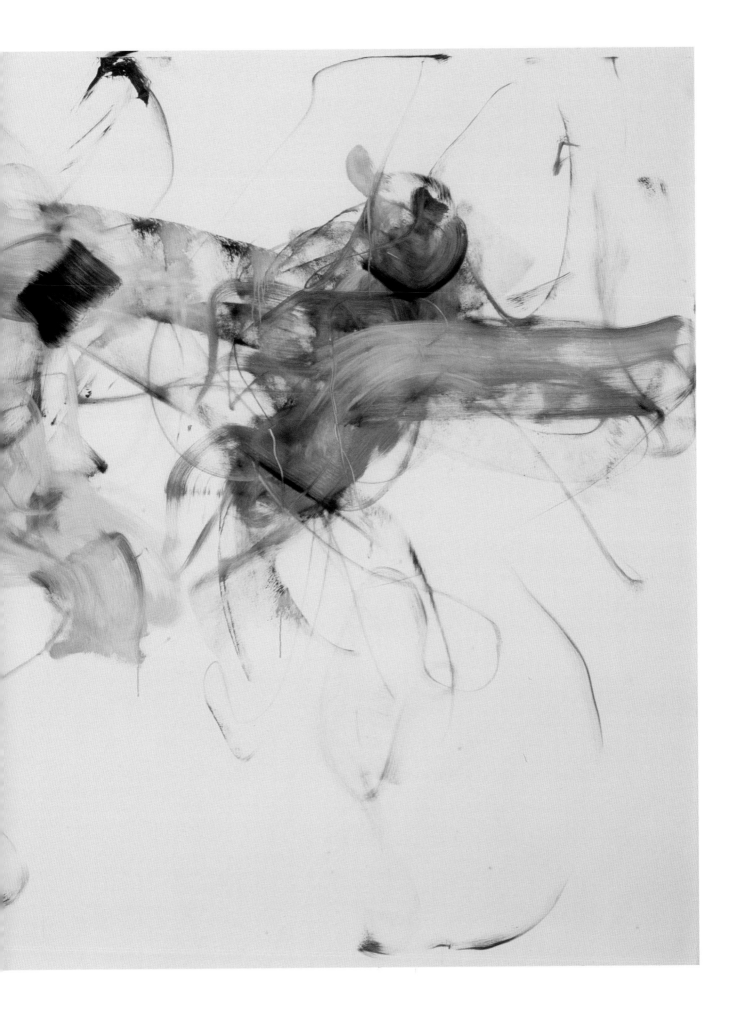

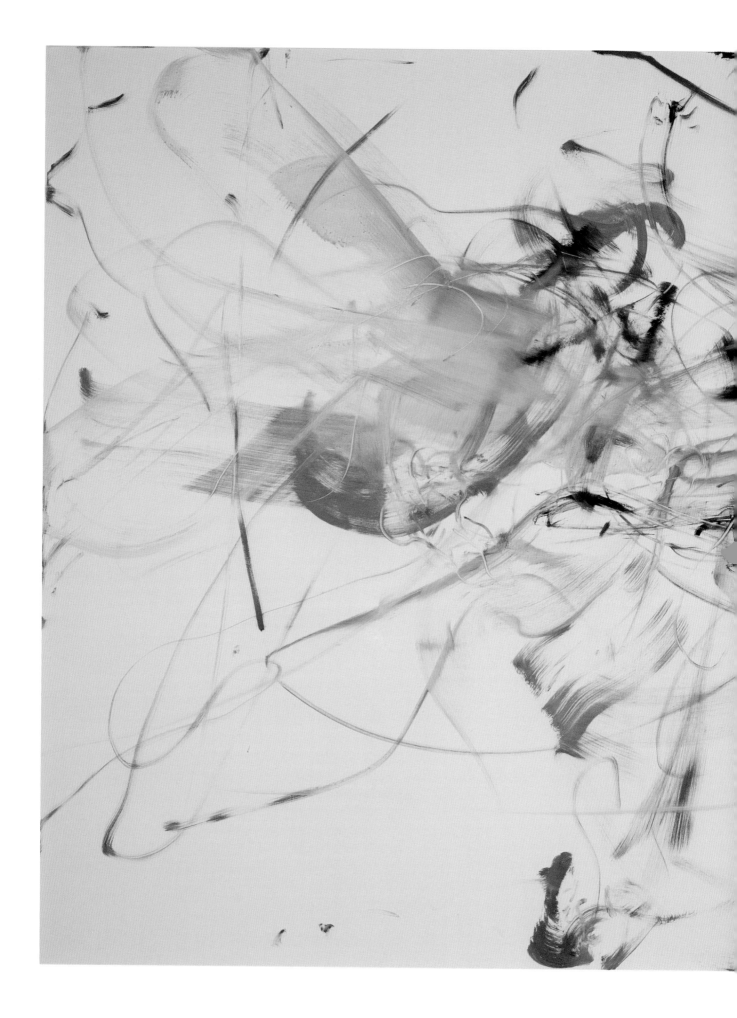

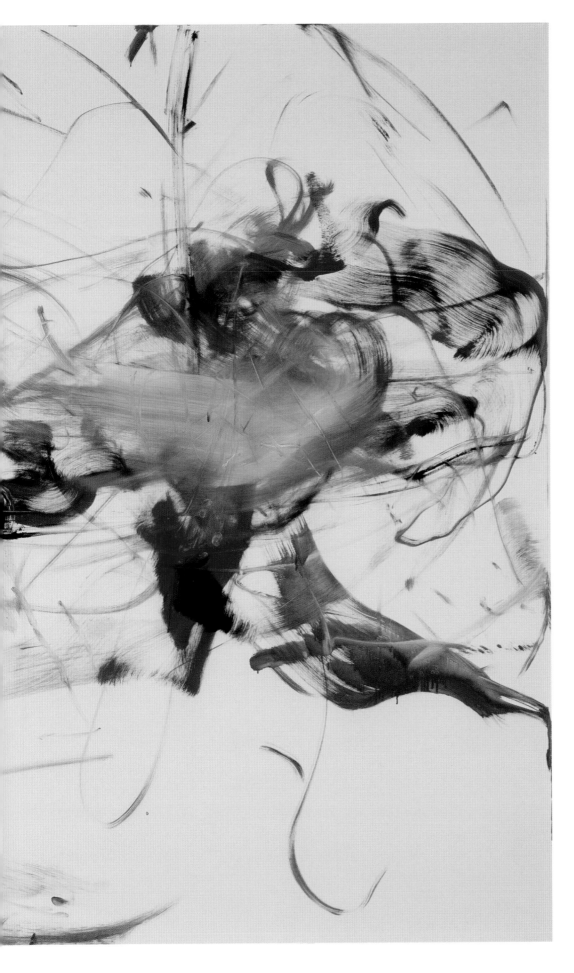

SONJA, 1999
OIL ON LINEN
78" X 110"

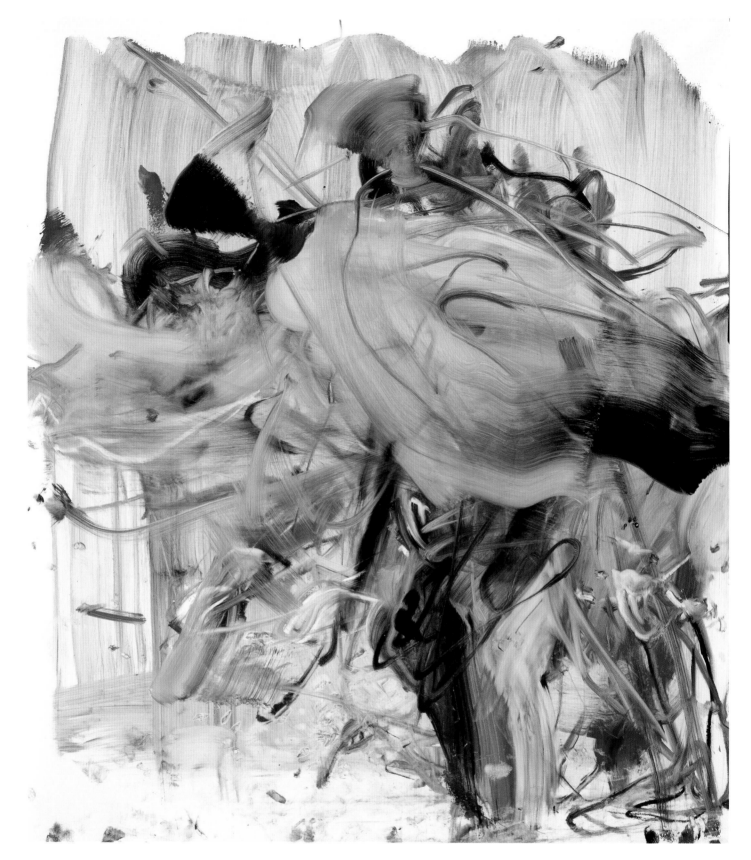

WOODY, 1998
OIL ON CANVAS
52" X 45"

SONJA #9, 1998
OIL ON LINEN
43"X 54"

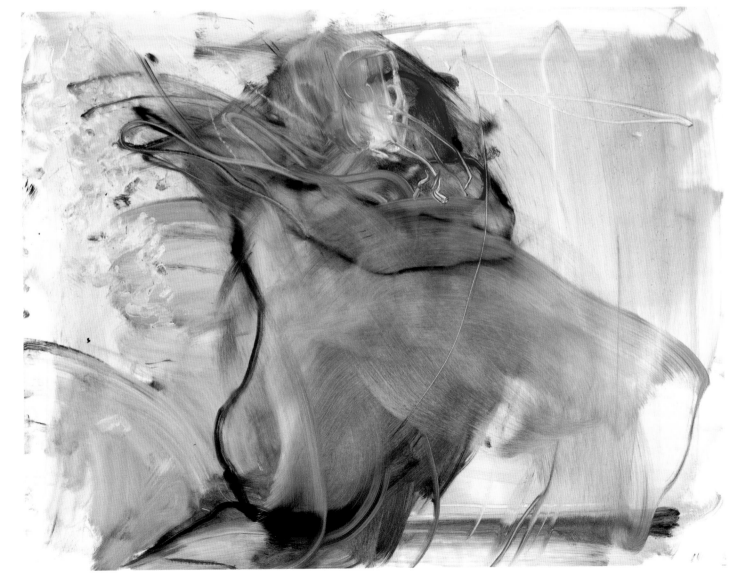

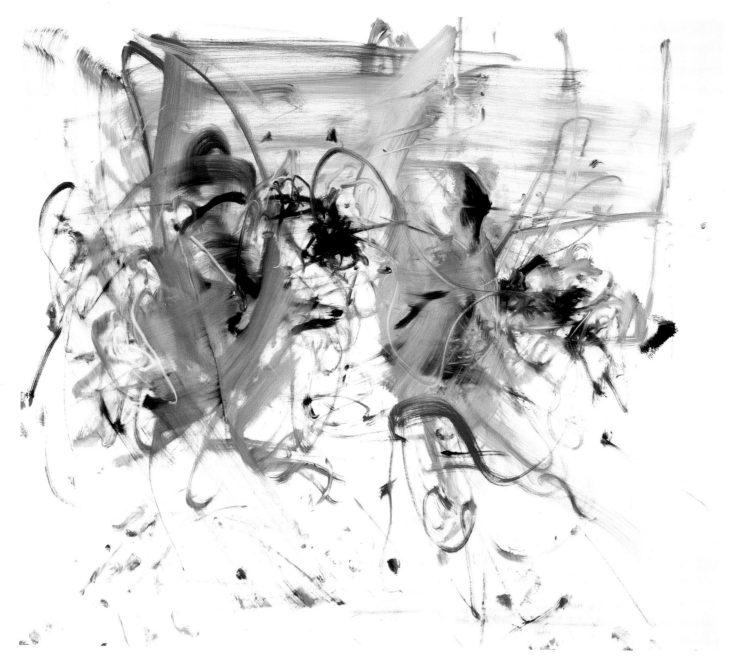

ROXANNA, 1998
OIL ON CANVAS
46" X 52"

AMY, 1997
OIL ON LINEN
42" X 53"

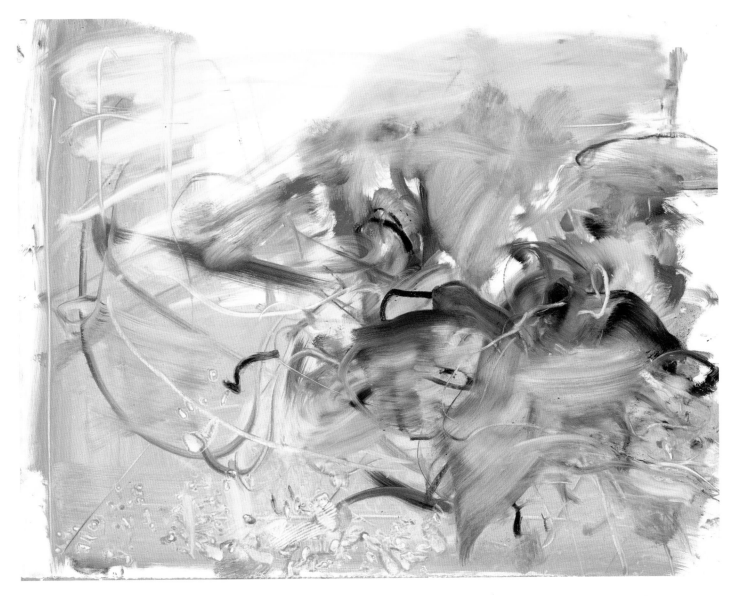

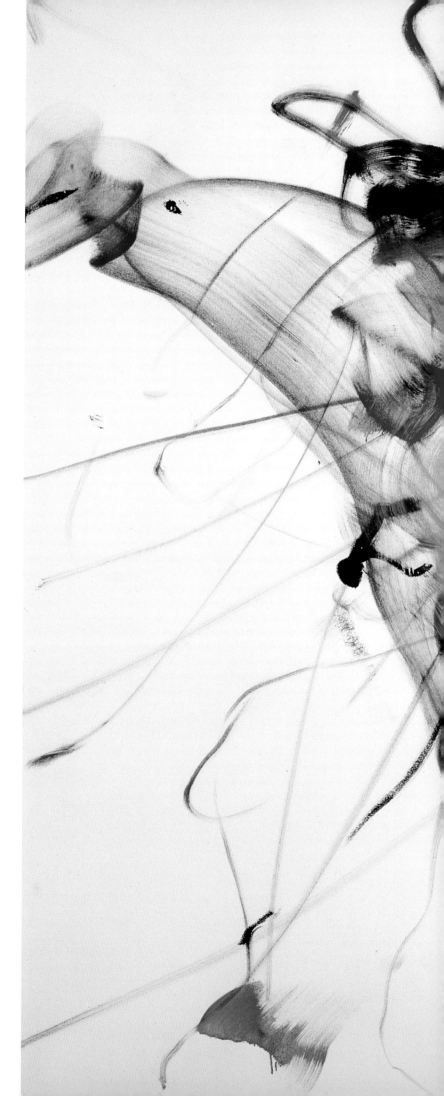

SONJA, 1997
OIL ON CANVAS
76" X 87"

FOLLOWING PAGE:
SUBDERMAL, 2002
MARK JARECKE / STEFFANY GEORGE
OIL ON LINEN
36" X 54"

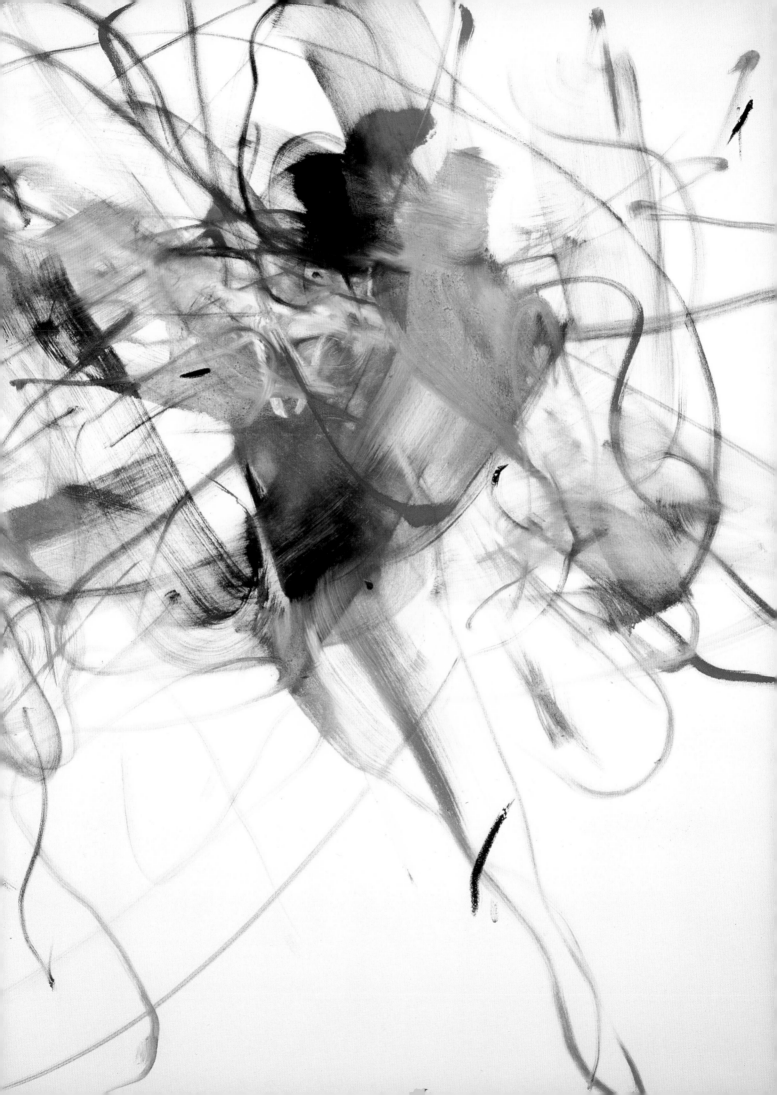

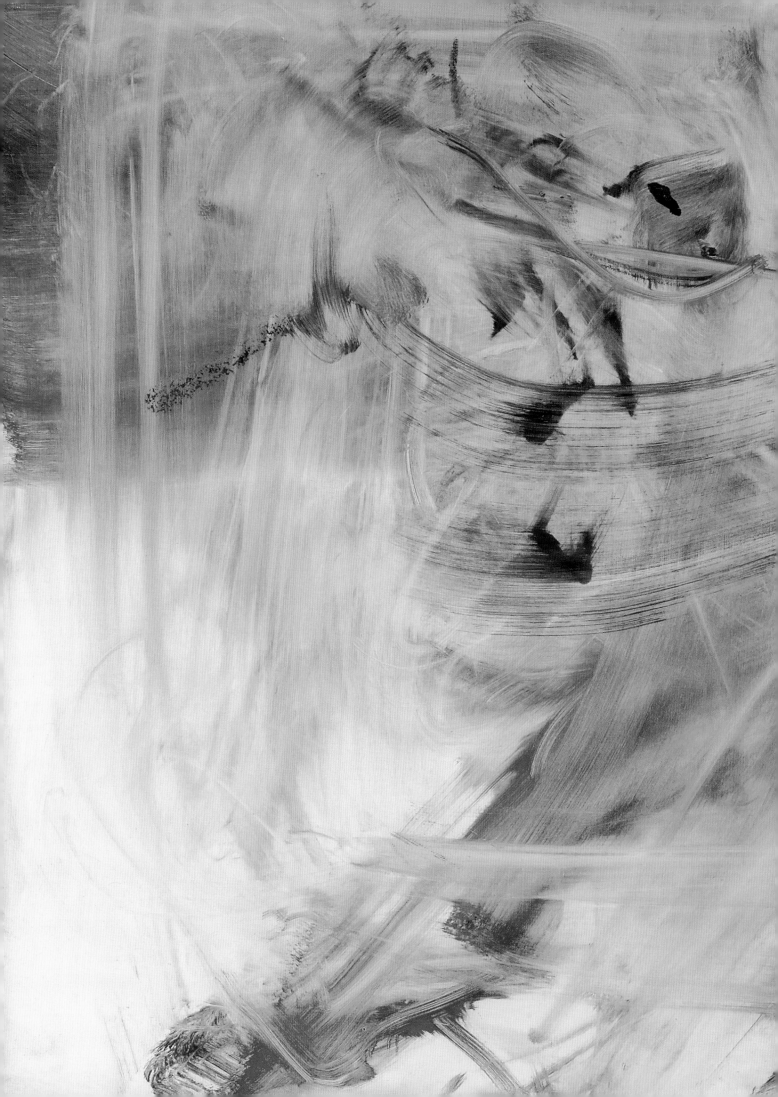

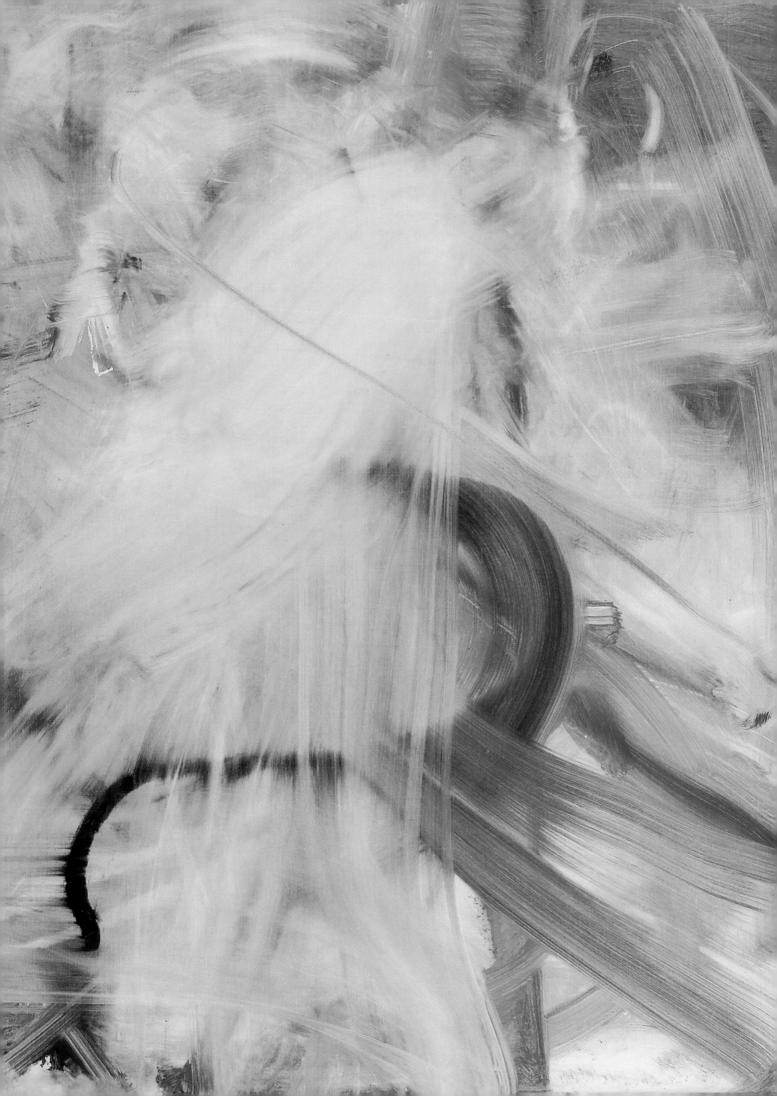

ON PAINTING ACTION:
AN INTERVIEW WITH TERRY ROSENBERG
RICHARD KENDALL

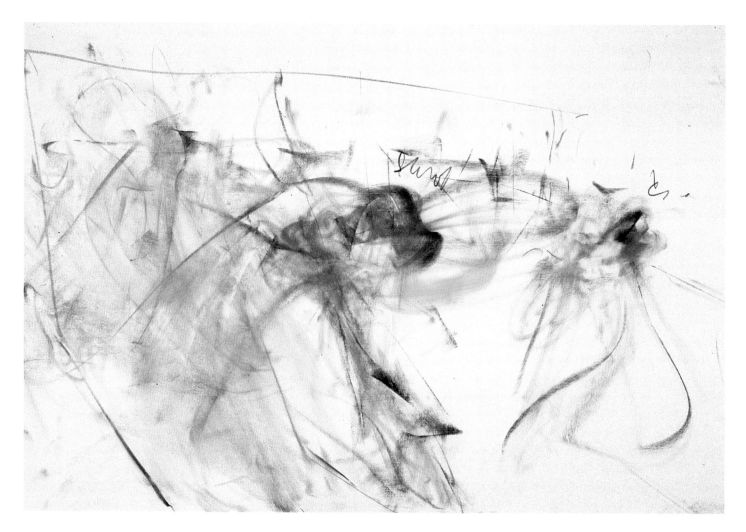

AUTO PUBLIK #7, 2001
MARK JARECKE
PASTEL, CHARCOAL AND GRAPHITE ON PAPER
27 1/2" X 39 1/2"

This interview was originally published in *NYARTS Magazine* in December, 2001:

The following conversation between the painter Terry Rosenberg and the art historian Richard Kendall whose upcoming publication and exhibition Degas and the Dance will soon open at Detroit Institute of Arts and Philadelphia Museum of Art. Kendall recently lectured about Rosenberg's work at the National Gallery, London in association with the exhibition Impression: Painting Quickly in France 1860-1890.

This discussion took place this summer as Rosenberg was preparing for an exhibition of his drawings and paintings. Rosenberg's subject for the last twenty years has been the human figure in motion. It is his practice to work during dancers' rehearsals, as such his work in a manner represents collaboration with such dance companies as the American Ballet Theatre, Mark Morris Dance Group, Bill T. Jones, and others. His work has been exhibited throughout the US and Europe and is represented in museum collections including Fine Arts Museums of San Francisco, Graphische Sammlung Albertina, and Brooklyn Museum of Art.

RK: I'm looking at the new drawings you've done and I'm seeing more words in the drawings than I'm used to seeing. Tell me how this happens and where these words come from.

TR: Dancers talk a lot about where, when, and how they're going to move and about patterns and body qualities. They count beats and spacing. So there's a lot of audio. As I write their words or numbers, they assume calligraphic and rhythmic qualities of words, music, numbers, changing spatial geometry, and the body merging. I try to keep myself open to respond to what they do, what they say, and I try to invent new ways to do this – risking making things way too complicated, way too incomprehensible. I can always throw the work away. The whole process and doing it rarely seems sensible. (laughs) When you get into drawing movement it becomes the source of creation. There are so many levels of things going on, it's really a messy business. The whole point of this strategy is it allows me to take the drawing to different places.

RK: There's a drawing in the studio where you've got a single word written across it. It's like a brush-mark, and it's the model's name. It functions as a reminder that a real model whose name you know was present with you in the studio. It isn't just anybody's name. Obviously, her name is important to you. It's an interesting echoing of the

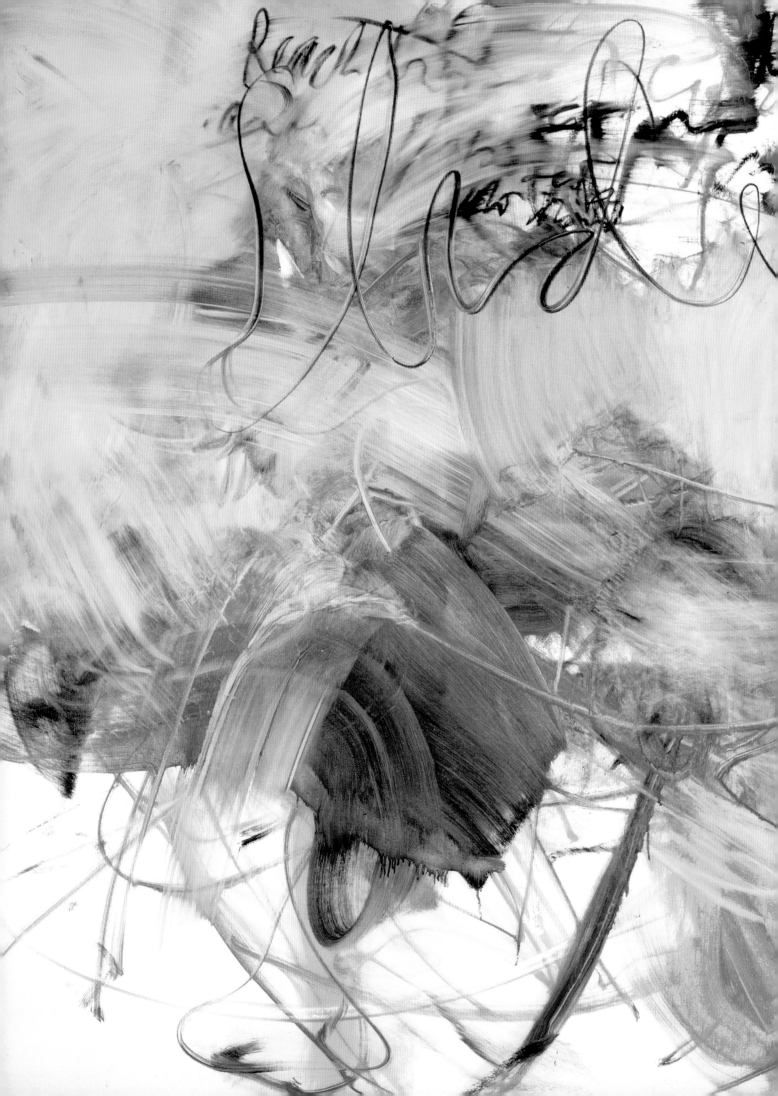

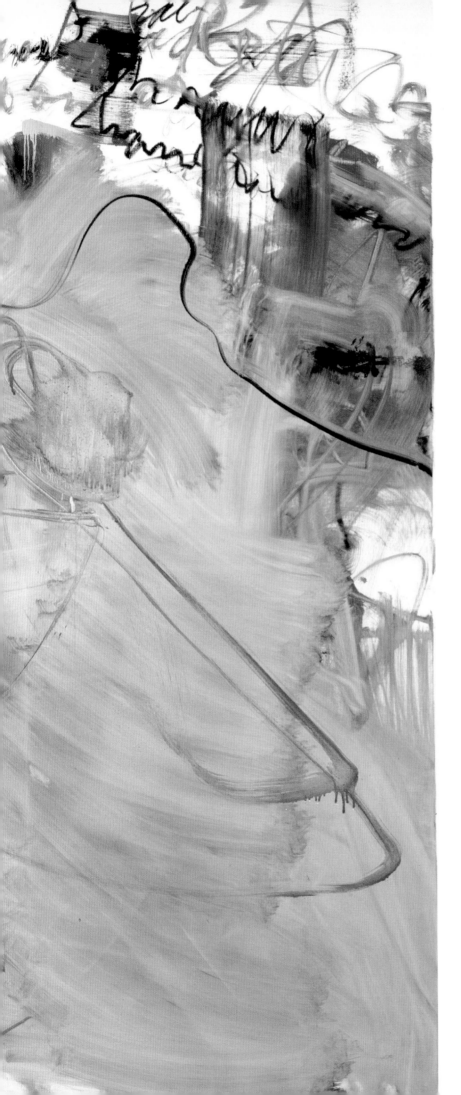

AUTO PUBLIK #1, 2001
MARK JARECKE (ANN HEDLY)
OIL ON LINEN
76" X 87 3/4"
PRIVATE COLLECTION, NEW YORK

traditional practice of the artist signing the drawing saying I was here. Instead you scribble the dancer's name across the top acknowledging that they are here as well.

TR: What I'm trying to do is form a union of consciousness with the dancer or group. It's a very intimate thing to draw someone moving like that: I have great respect for the dancers I work with, they reveal a lot about themselves through their movement. Being out there on stage is the ultimate risk. So, the drawing is a record of that, and there are also poetic qualities to their names. As for signing the work I always sign my work on the back.

RK: You were talking before about your collaboration with choreographer Wendy Rogers. It's an unusual collaboration because both of you are improvising in real time, you're both taking a risk in each other's presence.

TR: Wendy has described the relationships she has with her dancers, for instance doing a duet. I tried to find a way that she and I could have a similar relationship in terms of a duet. We came up with the possibility that she could respond to my drawings directly while she's dancing, by projecting the drawing on the wall. So we're trying in some way to use our two sensibilities, working in a place between the two art forms.

RK: Sometimes the writing comes together in a very innovative and suggestive way. It's almost like a graphic poem. You've even got the echo of a word in the drawing where the word is underneath. Some of the writing is legible and some isn't. Some of the drawing can be read as the body in movement and some could be any number of things, that wonderful level of legibility and illegibility, coherence and incoherence.

TR: When I'm drawing bodies in motion, form constantly disintegrates. Some of the drawings appear with what looks like a nucleus where form, light, words, and dynamic movement integrate or disintegrate. I'm drawing from a place where all these things collide and continuously change. It is inherent when focusing on the moment of creation, the ever-changing present.

RK: So instead of just doing what is already an incredibly difficult thing, which is making an image on a piece of paper of a body that's in movement, you're also introducing two other dimensions, the dimension of words and the dimension of music. It's not just one challenge it's three simultaneously. And it's almost as if you put yourself at the

nexus of these three different worlds, where they collide, and try to make art in this immensely complex multidimensional spot.

TR: I'm trying to get a sense of this atmosphere, and moments in time. The complexion of all these things has a kind of logic from which I draw. Although it seems wildly illogical, there's something about the dynamism of the structure of all of it that has a precarious balance to it. It's the combination of the dynamic yet ephemeral nature of moments of creation that really hold my attention. I found a diagram relating to the speed of light several years ago. It indicates that as you accelerate toward light speed the present expands as the past and future diminishes. Moving objects tend to stand still. It clearly explained what I was experiencing when focusing in the present drawing dance. My intuition tells me that in the future, we're all going to be speeding through space, different kinds of space than we now know, relying on newly developed senses to guide us through.

RK: Several of the things you're talking about movement, music, and space, are abstract entities. It's as if you're moving into a more imprecise, nebulous universe of energy, time, and sound rather than what you have also tried to do, which is to make an image of an extraordinary torso or a sense of concentrated human presence in a particular space, at a particular moment

TR: The body is like a connective tissue between inner space and outer space that we can see and recognize moving through space here on Earth. When I look at these drawings they sometimes look like subatomic diagrams or images I've seen in science magazines, and also like outer space photographs of super nebula, although evidence of touch is very present. Drawing moving bodies in the present is a way to investigate primary forces and interpret them openly. Everything in the universe is made of particles, including our bodies, and the fact that this kind of energy comes through in the drawings is curious but not so surprising.

RK: But it's clearly a space that you're comfortable with, and one you're going into with your eyes wide open. You're interested by this resonance, even though it's grounded in dancers on their wooden floors in New York.

TR: I like that the work is open for interpretation. Some people would say it's figurative, and some people would say it isn't, and some would say both. People approach things

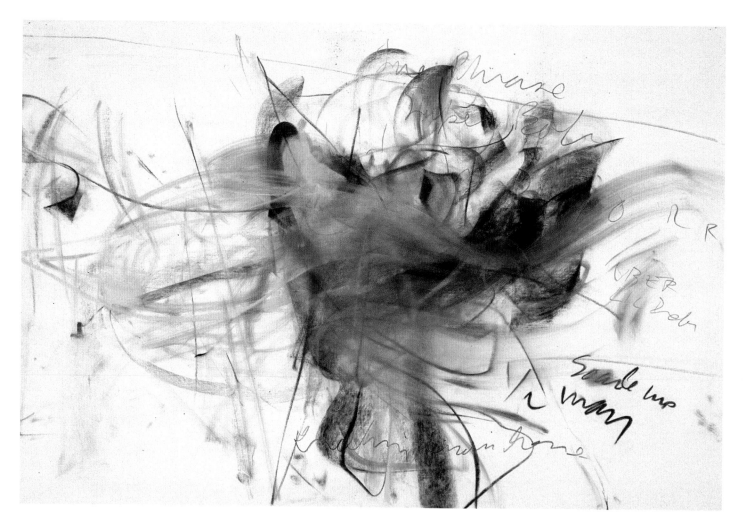

AUTO PUBLIK #11, 2001
MARK JARECKE
PASTEL, CHARCOAL AND GRAPHITE ON PAPER
27 1/2" X 39 1/2"

AUTO PUBLIK #22, 2001
MARK JARECKE
PASTEL, CHARCOAL AND GRAPHITE ON PAPER
27 1/2" X 39 1/2"

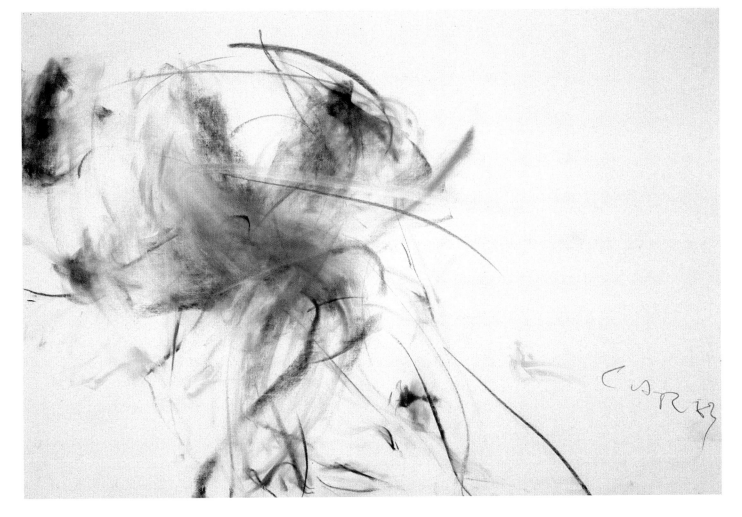

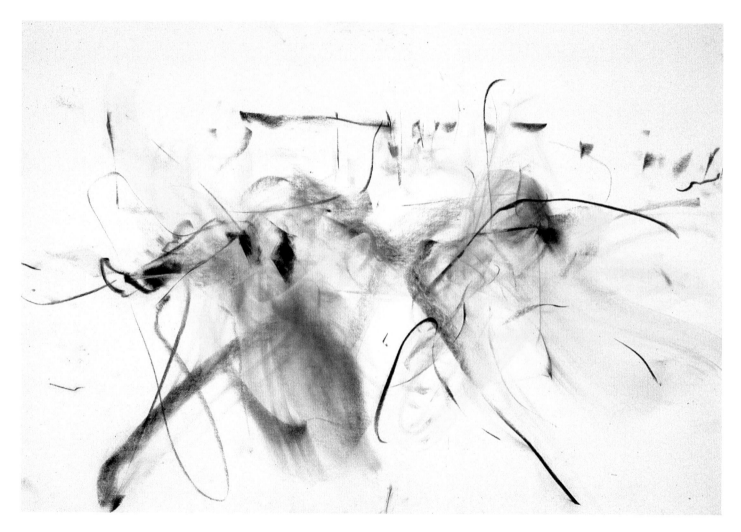

AUTO PUBLIK #15, 2001
MARK JARECKE
PASTEL, CHARCOAL AND GRAPHITE ON PAPER
27 1/2" X 39 1/2"

with different ideas, intelligence, and perceptions. Those things I mentioned, that I like to read and think about, naturally make their way into the work.

RK: But they are not necessarily things you want people to read back into your pictures.

TR: Well, I don't want there to be some sort of prerequisite text for someone to enjoy my work. I think the work operates on different levels.

RK: But you're also putting yourself in a place where someone who is quite new to your work, who just walked in off the street and saw your drawings on the walls might not even realize they have to do with dance. And that doesn't trouble you?

TR: No.

RK: You're happy for them to exist as pictures, as visual constructions that succeed or fail in their own right?

TR: Yes. I can't really control the response people have to my work. I try to provide the elements that are essential to make the work interesting to me and hopefully they will go forth and communicate to others.

RK: You can't control what people's response is but at the same time you are making things which have an identity and that identity is something that you have to come to terms with. And if you found that people were seeing them one way that was completely at odds with the way that you made them and that you felt about them you might get a bit troubled.

TR: I'm very curious to hear people's responses to my work. I've learned a great deal listening to those responses over the years. So I take it all in and then when I actually do the work I really just try to open myself up to that which I'm drawing, and try to put everything else that I know or I've learned or heard behind me. When I'm drawing movement I have to leave everything behind to be able to keep up with that kind of activity.

RK: That's a tough answer but it's surely the right one.

TR: When I say this activity is like a meditation; it is. It presents a lot of challenges for me to leave my own personal baggage behind. What I think my work should look like or mean, or what people are going to think, or what I think, all of those things I have

not much control over if truly focused on the subject. I am simply trying to draw the movement. And that is a wildly complex thing to do. So it made me realize that all those thoughts that come into my head clearly must be left behind on this trip.

RK: What of your choice of color? Do you accept it as arbitrary in some ways; reds and yellows don't correspond to the reds and yellows you see out there.

TR: It's not really arbitrary, nor am I using a natural palette exactly. Most often I'll be working in a studio and sometimes viewing the stage whose many variables (lighting, costumes, stage set, choreography, etc.) change each day. I don't know what a finished performance will look like until I see a dress rehearsal. So what I'm really concerned with is finding a relatively simple palette that best describes a synthesis of light, dynamic structure, and space-time relationships of the moment.

RK: You have also described to me a system where you pre-select certain colors and have them on your hands?

TR: Yes. I have a method where I put colors on a glove. I also cut a hole in a sock to get my thumb and hand through it, and wear it on my arm and put color there too. It eliminates choosing colors while I am drawing and painting which would take my concentration out of the moment. It was designed for speed, primitive as it is. A lot of color comes from an accumulation on my arm or on the glove. It's all happening at once. It's not like I'm picking this color and applying it and then picking another, instead I become a flexibly moving palette.

RK: When I've looked before at your drawings and paintings, I've seen the role of this process of erasing, which I think plays a very important part in your work. I've also noticed it in the context of your biggest paintings, the erasing in some passages is quite intense and complicated, unpredictable things happen with the paint. You rub something away and there is something wonderful underneath you couldn't possibly have known or constructed or imagined. To my eye, a dialogue is formed between those elements that are fairly controlled where you might be following a movement or describing a wall or a mirror, and these explosions of energy and movement and dynamism. I imagine that at a certain point you might find them to be too strong and intense, so you wipe it away and find this very subtle balance almost like a veil, a

beautiful veil across the front, suggesting a body, carving through space, or drifting across the floor.

TR: Often, the eraser gives me a way of bringing light to things, it is also used to open up space or add another dimension. Every once in a while I'll use an eraser to vary them just slightly, in an attempt to ease tensions in a drawing. Sometimes, I wonder whether on some level I sense what's under the layers, because I laid them down a few seconds earlier. I don't generally go back and work on drawings or paintings after the sessions, because I never can get into that space/time again. It inevitably becomes a futile formal exercise.

RK: There is something we have talked about before, and we'll probably be talking about in ten years' time. When you make a mark on a piece of paper or on canvas which is a free looping, risky arm-based mark you're in a territory where a lot of painters have been before, most notably the Abstract Expressionists. Is that part of the baggage you have to try to leave outside the room when you come in? Do you feel that there is some sort of affinity with what Pollock did when he was making his drip paintings or De Kooning with his ribbon paintings, or is that just something that's off your map?

TR: I've certainly been influenced by Abstract Expressionism, particularly the action painters. They were the first painters where you really see the artist's body present in a painting, most notably Pollock. I don't mean a picture of the body. He changed the whole approach, when everyone else was still painting with brushes. Action Painters broke open painting from a body standpoint, creating from their own nervous system their inner landscape as De Kooning put it. We begin to see more of the body present with Impressionism as the brush loosens as the artist makes quick impressions. The paint also starts to take on a life of its own.

While this informs my work, I'm working with these body dynamics in two ways, my own and that of a perceived subject, trying to match theirs in a way. My work is affected by another person or persons' movements, emotions, and intelligence opening my response system to theirs simultaneously, looping back in a way to artists painting from the model over centuries, but informed by other developments in art and science that have occurred up to the present.

RK: So what you've brought together here is again a challenging conjunction of elements, using a vocabulary growing out of New York painting of fifty years ago. But it is also about looking and experiencing bodies moving in space. Do you see that as a step back, or do you see it as a step beyond what the abstract expressionists were doing?

TR: Throughout history there are layers between great discoveries in our evolution. Depending on your perspective, whether you look forward in time or backward or you see through all the layers, certain moments in history speak to our soul. They are moments that we must address because they have relevance to the present. Between layers of history there are vast amounts of information that have been skipped over or never thoroughly investigated. They have been there all along but no one noticed. The same has happened with scientific discoveries about the universe. So I look toward Action Painting, its immediacy to give expression to the body and the freedom that comes with mobility in dance. It's the dance that brings human complexities to the work naturally. I find myself at times thinking, God these two dancers are doing this thing right in front of me that is just so beautiful! That's one of the other features of doing this kind of work that really holds my attention! It's unbelievable!

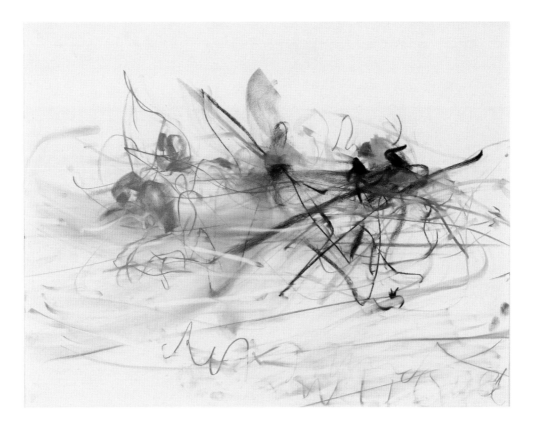

D-MAN IN THE WATER #30, 1999
BILL T. JONES / ARNIE ZANE DANCE COMPANY
PASTEL, CONTE CRAYON, CHARCOAL AND GRAPHITE ON PAPER
23" X 29"

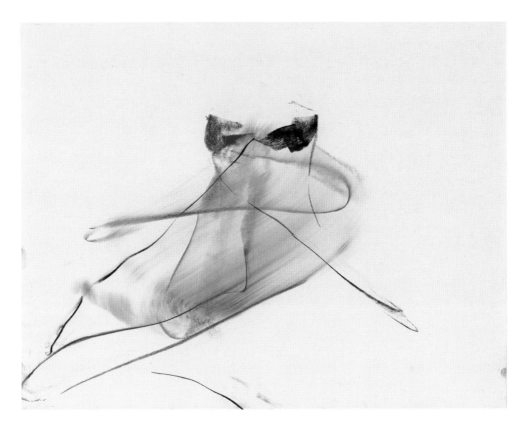

D-MAN IN THE WATER #4, 1999
BILL T. JONES / ARNIE ZANE DANCE COMPANY
CONTE CRAYON AND CHARCOAL ON PAPER
23" X 29"

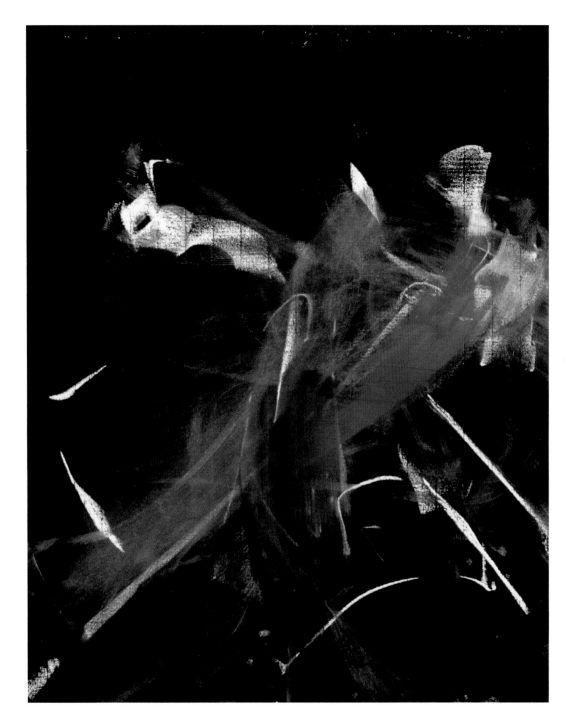

WENDY #18, 2000
PASTEL ON BLACK PAPER
25 1/2" X 19 1/2"

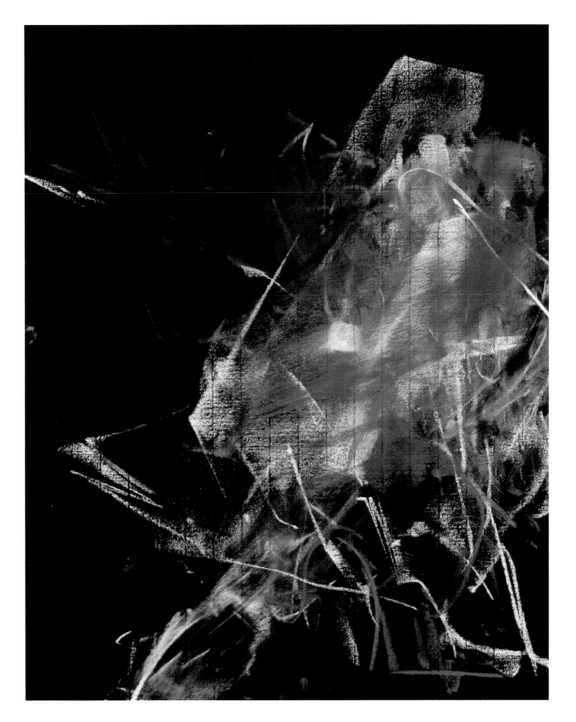

WENDY #22, 2000
PASTEL ON BLACK PAPER
25 1/2" X 19 1/2"

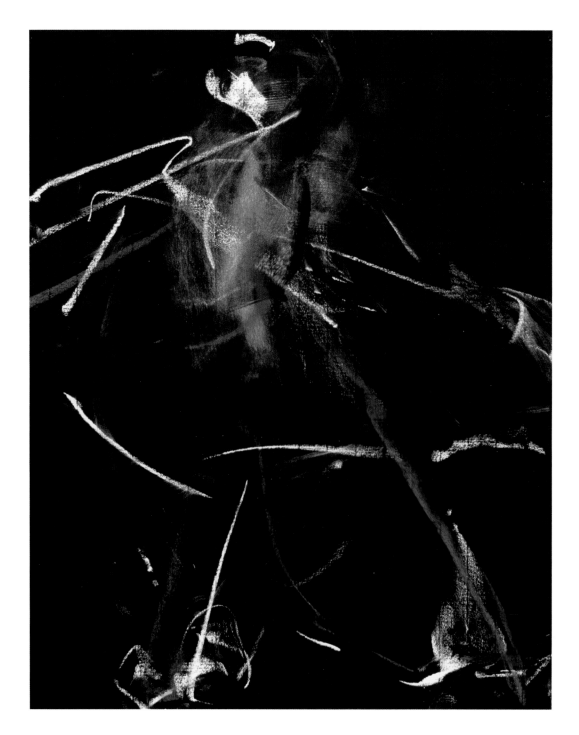

WENDY #23, 2000
PASTEL ON BLACK PAPER
25 1/2" X 19 1/2"

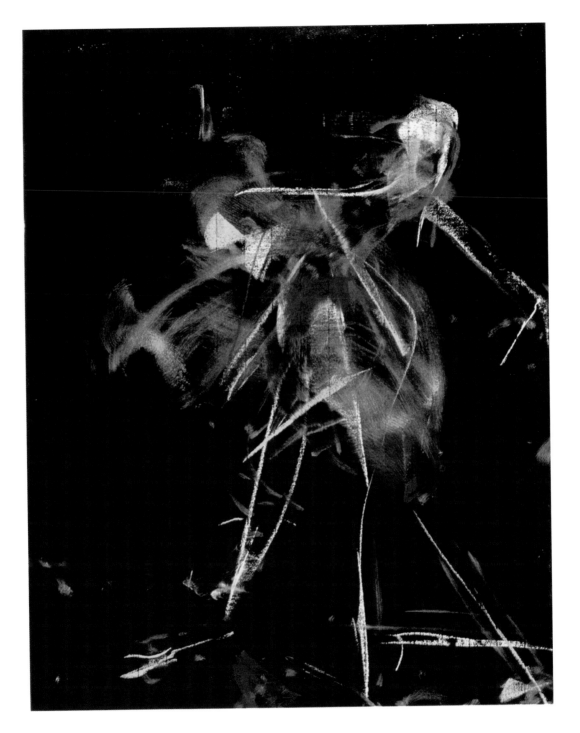

WENDY #10, 2000
PASTEL ON BLACK PAPER
25 1/2" X 19 1/2"

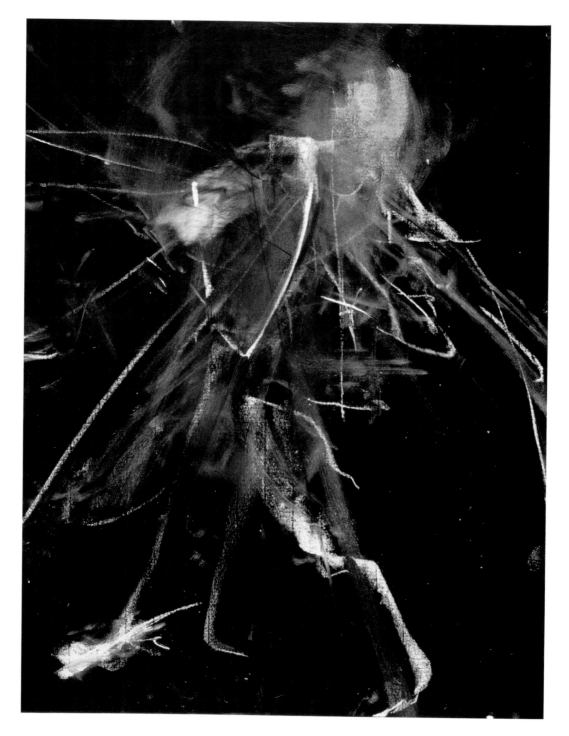

WENDY #27, 2000
PASTEL ON BLACK PAPER
25 1/2" X 19 1/2"

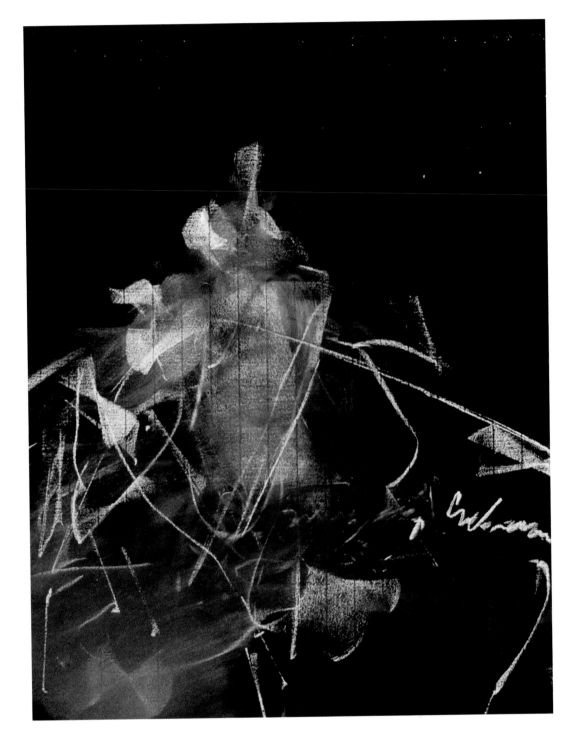

WENDY #13, 2000
PASTEL ON BLACK PAPER
25 1/2" X 19 1/2"

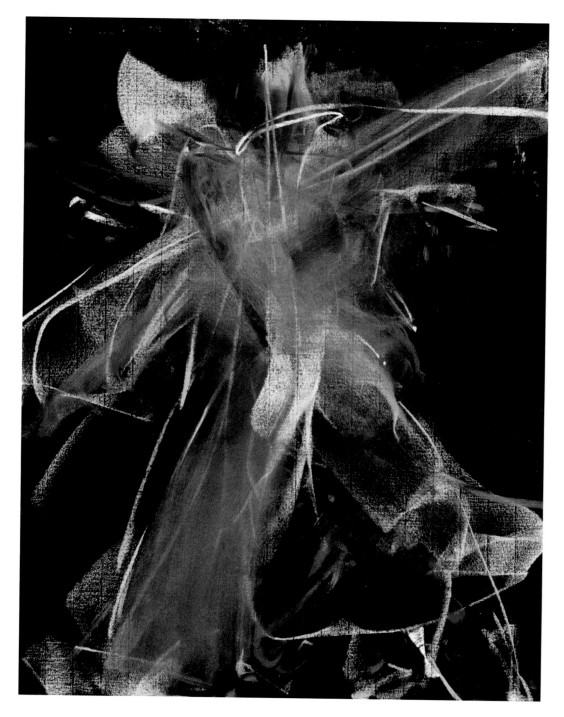

WENDY #9, 2000
PASTEL ON BLACK PAPER
25 1/2" X 19 1/2"

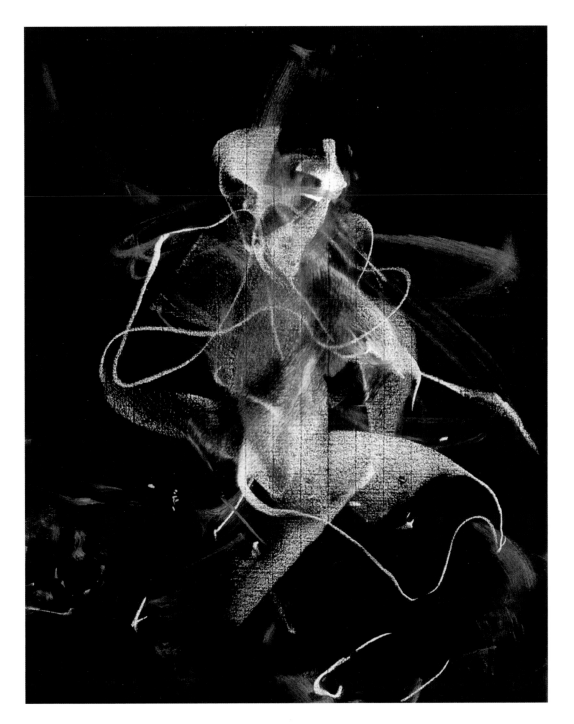

WENDY #4, 2000
PASTEL ON BLACK PAPER
25 1/2" X 19 1/2"

ACKNOWLEDGEMENTS

The development of this work, exhibitions, and catalogue would not be possible without the generosity of the following individuals. To you my warmest thanks.

Ed Aguilera, DD Allen, Allyson Green, Dr. Adrian and Sally Almquist, Barry Alterman, Guido Alvarez, Bjorn Amelan, Andrew Baran, BBQ Productions, Tim Bruce, Ann Brugenhemke, Arlene Bujese, David Bulasky, Terese Carpenter, David Catalan, Curtis Cates, Lanie Cecula, Marek Cecula, Dawn Cieplensky, D.O., David Clark, Cindy Connolly, Susan Davis, Blane De St Croix, Daphne Anderson Deeds, Jill DeVonyar, Diane Dubler, Martha Eddy, Claudia Einecke, Robert Eisenberg, Gulsun Erbil, Janet Farbor, Cece Fenton, Larry Ferguson, Nicholas Giorgio, Ellen Goldman, Dan Gurlitz, Penny Hacthell, Anna Harlas, Cynthia Henthorn, Doug Hiner, Corrie E. Horshinski, D.C. Woody Howe, Dr. Thomas Huerter, Forrest Hughes, Dr. Darryl Isaacs, Steve and Kathleen Jamrozy, Kenneth Jedding, Jia Min, Shirley Kaneda, Jun Kaneko, Karakas Charitable Foundation, Nicholas Karakas, Athina Karamalas, Richard Kendall, Terry and Mary Beth Koopman, Monte Kruse, Kevin Lawler, Liza Lerner, Mary Loving, Loving and Company, Lowercase Incorporated, Naomi Lukov, Martin Magnuson, Manuccia Mandelli, Geoffrey Mark, Terri Marlow, Amy Matthews, Sandy and Bill Matthews, Ransom Mayfield, Charna Meyers, Colleen Miloni, Miriam Tuncer, Dr. James and Lana Morgan, Rebecca Morgan, John Mosley, Christina Narwicz, Roy Nathanson, Beth Netter, Barbara O'Keefe, Saul Ostrow, Pasquale Pagnotta, Mary Jo Pane, SeRok Park, Tom Patchett, Carol Paumgarten, Burt Payne 3, Tappy Phillips, Photographics, John Prouty, David and Megan Radler, Jorge Paez Roberosa, Carl and Jane Rohman, Evelyn Rosenberg, Jay Rosenberg, Martin Rosenberg, Ree Schonlau, Deniz Seran, Barbara Setembrini, Clifford and Barbara Shaffer, Linda and Howard Shrier, Todd Simon, Colin Smith, Spazio Krizia, Steps on Broadway, Bette Stoler, John Taylor, Peter Terezakis, John Tjenos, John Todor, Nancy Umanoff, Isa Vercelloni, Orio Vergani, David Wintroub, Henry Wojdyla

Without the following choreographers and dancers this body of work would not exist. I would like to express my eternal thanks for your willingness to share your deeply human and moving activities.

American Ballet Theatre, Natsuki Arai, Maxim Belotserkovsky, Bill T. Jones/Arnie Zane Dance Company, Julio Bocca, Sandra Brown, Jose Manuel Carreno, Yan Chen, Dance Theatre of Harlem, Irina Dvorovenko, Christina Fagundes, Alessandra Ferri, Steffany George, Marcelo Gomes, Guillaume Graffin, Ann Hedly, Paloma Herrera, Robert Hill, Susan Jaffe, Mark Jarecke, Bill T. Jones, Julie Kent, Kirov Ballet, Irina Kolpakova, Arlene Lorre, Vladimir Malakhov, Mark Jarecke Dance, Mark Morris Dance Group, Amy Matthews, Kevin McKenzie, Amanda McKerrow, Miami City Ballet, Arthur Mitchell, Mark Morris, Gillian Murphy, Toshiko Oiwa, Parsons Dance Company, David Parsons, Sonja Perreten, Neta Pulvermacher, Antonio Ramos, Brittany Reese, Ann Reinking, Wendy Rogers, Jeanne Ruddy, Sara Rudner, Bala Sarasvati, Gennadi Saveliev, John Selya, Lynda Sing, Rebecca Stenn, Ethan Stiefel, Ashley Tuttle, Cary Twomey, Edward Villella, Michelle Wiles, Roxanna Young

1954 Born Hartford, Connecticut, Lives and works in New York City

SOLO EXHIBITIONS

1980 Hal Bromm Gallery, New York City
1981 Paul Mellon Arts Center, Wallingford, Connecticut
 Philadelphia College of Art, Philadelphia, Pennsylvania
1982 Hal Bromm Gallery, New York City
 Roger Ramsay Gallery, Chicago, Illinois
1983 Hal Bromm Gallery, New York City
 Institute of Art and Urban Resources, The Clocktower, New York City
1984 Frances Wolfson Art Gallery, New World Center, Miami-Dade Community College, Miami, Florida
 Bette Stoler Gallery, New York City
1985 Francis Colburn Gallery, University of Vermont, Burlington
1986 Galerie Silvia Menzel, Berlin, Germany
 Bette Stoler Gallery, New York City
 Hillman Holland Fine Arts, Atlanta, Georgia
1987 Bemis Foundation, Omaha, Nebraska
 Brompton Gallery, London, England
1988 Jon Oulman Gallery, Minneapolis, Minnesota
 Sharpe Gallery, New York City
1989 Jon Oulman Gallery, Minneapolis, Minnesota
1991 Bemis Center for Contemporary Arts, Omaha, Nebraska
1993 Gallery of Art and Art History, University of Nebraska, Lincoln
 BM Contemporary Art Center, Istanbul, Turkey
 Creighton University Art Gallery, Omaha, Nebraska
 Bemis Center for Contemporary Arts, Omaha, Nebraska
1994 Sheldon Memorial Art Gallery, Lincoln, Nebraska
2000 Benjamin N. Cardozo Gallery, Brookdale Center, Yeshiva University, New York City
2001 Danspace Project, Saint Marks Church, New York City
 Gallery X, New York City
2002 Spazio Krizia, Milan, Italy
 Coral Springs Museum of Art, Coral Springs, Florida
2003 Gallery of Art and Design, Southwest Missouri State University, Springfield, Missouri
 Bemis Center for Contemporary Arts, Omaha, Nebraska

SELECTED GROUP EXHIBITIONS

1975 *Florida Sculpture*, Norton Museum, Palm Beach, and Metropolitan Museum, Miami, Florida
1976 *Hortt Annual*, Fort Lauderdale Museum of Fine Arts, Fort Lauderdale, Florida
 Objects, Miami-Dade Community College, North Campus Gallery, Miami, Florida
1977 *Site Specific*, Artpark, Lewiston, New York
 Ceramic Sculpture, Roland Gibson Gallery, State University of New York, Potsdam, New York
1978 *Works in the World*, University of Illinois, Champaign-Urbana
1979 *Arts Industry*, John Michael Kohler Arts Center, Sheboygan, Wisconsin
 Small Works, Washington Square East Galleries, New York University, New York City

1980 *Maximum Coverage: Wearables by Contemporary American Artists*, John Michael Kohler Arts Center, Sheboygan, Wisconsin

Major Sculptural Works produced at the Kohler Company, Slusser Gallery, University of Michigan, Ann Arbor

1981 *Drawings*, Hal Bromm Gallery, New York City

U. S. Art Now, Nordiska Kompaniet, Stockholm, and Konsthallen, Goteborg, Sweden

Selections from Hal Bromm, New York, Eaton/Shoen Gallery, San Francisco, California

Figuratively Sculpted, Institute for Art and Urban Resources, P.S.1, Long Island City, New York

1982 *Personal Iconography*, The Sculpture Center, New York City

Agitated Figures: The New Emotionalism, Hallwalls Contemporary Arts Center, Buffalo, New York, and Hal Bromm Gallery, New York City

Great Big Drawings: Contemporary Works on Paper, Hayden Gallery, Massachusetts Institute of Technology, Cambridge, Massachusetts

Painting and Sculpture Today 1982, Indianapolis Museum of Art, Indianapolis, Indiana

The UFO Show, Queens Museum, Queens, New York

Great Big Drawings, Roger Ramsay Gallery, Chicago, Illinois

Selections from the Collection of Jim and Danielle Sotet, University of Maryland Art Gallery, College Park, Maryland

1983 *39th Ceramics Annual*, Lang Gallery, Scripps College, Claremont, California

Flag of the Eighties, Institute for Art and Urban Resources, P.S.1, Long Island City, New York

Sculpture Penn's Landing, Cheltenham Art Centre, Cheltenham, Pennsylvania

Intoxication, Monique Knowlton Gallery, New York City

The Raw Edge: Ceramics of the Eighties, Hillwood Art Museum, Long Island University, C.W. Post Campus, Brookville, New York, and Everson Museum, Syracuse, New York

Paintings and Drawings, Bette Stoler Gallery, New York City

1984 *A Passionate Vision: Contemporary Ceramics from the Daniel Jacobs Collection,* De Cordova Museum, Lincoln, Massachusetts

Drawings, Greene Gallery, Miami, Florida

Arabesque: Grand Gestures in Painting, Sculpture, and Decorative Arts, Bette Stoler Gallery, New York City

Modern Masks, Whitney Museum of American Art at Philip Morris, New York City

Drawings, The Sculpture Center, New York City

1985 *Between Science and Fiction,* Sao Paulo Bienal, Sao Paulo, Brazil

Benefit for Franklin Furnace, Ronald Feldman Gallery, New York City

1986 *Two Person Exhibition*, with Lee Jaffe, Forum, Zurich, Switzerland

1987 *Selected Works from the Bemis Foundation,* Creighton University Art Gallery, Omaha, Nebraska

The Eloquent Object: The Evolution of American Art in Craft Media Since 1945, Philbrook Art Center, Tulsa, Oklahoma; travels to; Virginia Museum of Fine Arts, Richmond; Oakland Museum, California; Boston Museum of Fine Arts, Massachusetts; Chicago Cultural Center, Illinois

Art Against AIDS, Bette Stoler Gallery, New York City

The Interior Self: Three Generations of Expressionists View of the Human Image, Montclair Art Museum, Montclair, New Jersey

Drawings, Bemis Foundation, Omaha, Nebraska

1988 *Civilized Life: An Alternative Look at Architecture,* Art Awareness Gallery, Lexington, New York

1989 *Sculpture from the Bemis Foundation,* Contemporary Art Center, Kansas City, Missouri

Gallery Group, Sharpe Gallery, New York City

Selections from the Bemis Foundation, Sheldon Memorial Art Gallery, Lincoln, Nebraska

1990 *Erotic Images in Art,* Jon Oulman Gallery, Minneapolis, Minnesota

Gallery Group, Sharpe Gallery, New York City

1991 *Contemporary Sculpture from the Collection of the Virginia Museum of Fine Arts,* Virginia Museum
of Fine Arts, Richmond, Virginia

Midwest Sculpture, Sioux City Art Center, Sioux City, Iowa (curated by George Neubert)

1992 *Off the Wall,* Sheldon Memorial Art Gallery, Lincoln, Nebraska

1993 *Kansas City Artists Coalition Drawing Invitational,* Kansas City, Missouri (curated by Deborah Scott)

From the Studios: New Work by Resident Artists, Bemis Center for Contemporary Arts, Omaha

Summer Show, Jan Weiner Gallery, Kansas City, Missouri

1994 *Drawings by Sculptors,* Albright Knox Art Gallery, Buffalo, New York

1995 *The Inspiration of Astrophysical Phenomenon,* Castel Gandolfo, Specola Vaticana, Italy

1996 *Chairmania,* Museum at the Fashion Institute of Technology, New York City, National Building
Museum, Washington, D.C., Pacific Design Center, Los Angeles, Chicago Athenaeum, Illinois

1997 *Recent Acquisitions: Works on Paper,* Joslyn Art Museum, Omaha, Nebraska

1998 *Paintings from the Bemis Center for Contemporary Arts,* Sioux City Art Center, Sioux City, Iowa

2000 *Claude Parent: An Oblique Lineage, Drawings and Models by Architects and Artists,* Louis Stern
Fine Arts, Los Angeles, California

Lyrical Visions: Music and Dance in American and Native American Art, Montclair Art Museum,
Montclair, New Jersey

Arts Industry: A 25-Year Collaboration, John Michael Kohler Arts Center, Sheboygan, Wisconsin

Summer Show, Sherry Leedy Contemporary Art, Kansas City, Missouri

Human Touch, Gallery X, New York City

The Notion of Motion, Islip Art Museum, East Islip, New York

Snapshot, Contemporary Museum, Baltimore, Maryland, travels to; Beaver College, Fine Arts Gallery,
Glenside, Pennsylvania, Aldrich Museum of Contemporary Art, Ridgefield, Connecticut

2001 *Prelude,* a performance with choreographer Wendy Rogers, Joyce Soho, New York City

Abstraction: 60 Years/60 Artists, Arlene Bujese Gallery, East Hampton, New York

20 Years of Excellence Part I & II, Bemis Center for Contemporary Arts, Omaha, Nebraska

2002 *Reactions,* Exit Art, New York City, and Alyce de Roulet Williamson Gallery, Art Center College of
Design, Pasadena, California

20/20 Vision, Bemis Center for Contemporary Arts, Omaha, Nebraska

MIART, Milan Art Center, Milan, Italy

On Paper/ Of Paper, Arlene Bujese Gallery, East Hampton, New York

Decimo Aniversario, Museo de Arte Contemporanio de Oaxaca

Physical Units: Fragments of the Human Form, Bronx River Art Center, Bronx New York

SELECTED BIBLIOGRAPHY

1981 Tatransky, Valentin, <u>ARTS</u> Magazine, 2/81

Donohoe, Victoria, *Banshees,* <u>The Philadelphia Inquirer,</u> 9/11/81

Larson, Kay, <u>New York</u>, 9/16/81, P.120

1982 Upshaw, Reagan, *Figuratively Sculpted at P.S. 1,* <u>Art in America</u>, 3/82

Bannon, Anthony, *Spiritual Art Rises Above the Ordinary,* <u>Buffalo Evening News</u>, 4/6/82

Moufarrege, Nicholas, <u>New York Native</u>, 4/12-25/82

Taylor, Robert, *Great Big Drawings, Sometimes They Work,* <u>The Boston Globe</u>, 4/18/82

Baker, Kenneth, *Drawing Conclusions,* <u>The Boston Phoenix</u>, 4/20/82

Glueck, Grace, *Gallery View, Emoting Over the Figure,* <u>The New York Times</u>, 5/30/82 S. 2, P.27

Kuspit, Donald, *Agitated Figures: The New Emotionalism,* <u>Artforum</u>, Summer 82

Moufarrege, Nicholas, *The 1982 Nike Awards,* <u>New York Native</u>, 7/15-18/82

Artner, Alan, <u>Chicago Tribune</u>, 8/6/82

Olmstead, Bob, <u>Chicago Sun Times</u>, 8/15/82

Moufarrege, Nicholas, <u>ARTS Magazine</u>, 9/82

Artner, Alan, *Rosenberg's figures add up to fine solo exhibition*, <u>Chicago Tribune</u>, 11/26/82, S-3, P.11

1983 Artner, Alan, *Art'82, Best Shows*, <u>Chicago Tribune</u>, 1/2/83

<u>Art in America</u>, *1982 in Review: The Galleries, Outstanding Solos*, Annual: P.16

Larson, Kay, <u>New York</u>, 10/3/83

Levin, Kim, *Voice Choices*, <u>The Village Voice</u>, 10/26/83

1984 Glueck, Grace, *Art: Dove's Paintings and Other Extractions*, <u>New York Times</u>, 11/9/84, C-23

Glueck, Grace, *Critics' Choices for Thanksgiving Holiday Weekend*, <u>The New York Times</u>, 11/23/84

Kohen, Helen L., *Weekend*, <u>The Miami Herald</u>, 2/3/84

McTwigan, Michael, *A Passionate Vision: The Collector Daniel Jacobs*, <u>American Ceramics 3</u>, 2/24/5

Taylor, Robert, P*lay, Passion Revealed in Ceramics*, <u>Boston Sunday Globe</u>, 4/15/84

<u>Interior Design</u>, *Kips Bay '84*, Vol. 55, N. 9, 9/84, P.229

Slesin, Suzanne, *Show House, Rooms with a Personal Touch*, <u>The New York Times</u>, 11/23/84

Brenson, Michael, *Modern Masks*, <u>The New York Times</u>, 2/28/84

1986 Scott, David Clark, *Barbara and Ira Sahlman with 'Untitled' by Terry Rosenberg*,
<u>The Christian Science Monitor</u>, 6/20/86

1987 MacMillan, Kyle, <u>Omaha Sunday World Herald</u>, 3/15/87 P.18

Sanchez, Lynn, *Rosenberg Draws on Subconscious*, <u>Metropolitan</u>, 3/4/87

Zimmer, William, *Expressionism Across the Generations at Montclair Museum*, <u>The New York Times</u>,
S. IINJ: P.22, C-1, 3/29/87

1988 Stang, Melissa, *Body Snatchers*, <u>Art Paper,</u> 5/88

Kimmelman, Michael, *Sculptors Make a Case for Expressionism*, <u>The New York Times</u>, 8/19/88

1991 Nusbaum, Elliot, *Sculpture from today's Midwest*, <u>Des Moines Sunday Register</u>, 7/28/91

1992 Walz, Kevin, *Residential Loft, New York*, <u>Domus,</u> Numero 737, 4/92

1993 MacMillan, Kyle, *Artists United by Bemis Residency, 'From the Studios' an Exhibit of Contrasts*, <u>Omaha Sunday World Herald</u>, 1/24/93

MacMillan, Kyle, *Profile: Artist Finds Space, Peace in Omaha*, <u>Omaha Sunday World Herald</u>, 3/14/93

Thorson, Alice, *Art Trek*, <u>The Kansas City Star</u>, 4/23/93, G-25

MacMillan, Kyle, *Works Imbued With Freedom*, <u>Omaha Sunday World Herald</u>, 5/23/93

Rosenberg, Terry, *Moondance*, <u>Dance Ink</u>, Summer P.23

Madra, Beral, *Terry Rosenberg, Projections*, <u>Cosmopolitan</u> (Turkey) 10/93, P.46

1994 Lavigne, Paula, *Two Dimensions Capture Fluid Movement of Dance*, <u>Daily Nebraskan</u>, 11/15/94

1995 MacMillan, Kyle, *Choreography of the Hand, Terry Rosenberg Captures Essence of Movement in Dance*, <u>Omaha Sunday World Herald</u>, 1/15/95

MacMillian, Kyle, *By the Line*, <u>Omaha World Herald</u>, 1/24/95

1996 Rosenberg, Terry, *Projections, Inspiration of Astrophysical Phenomenon*, <u>Leonardo</u>, Volume 29, No. 2, PP.155-157, 1996, By M.I.T. Press

1997 MacMillan, Kyle, *Joslyn Acquisitions Works on Paper*, <u>Omaha World Herald</u>, 6/8/97

1998 MacMillan, Kyle, *Sioux City Showcases Bemis Talent*, <u>Omaha World Herald</u>, 5/24/98

1999 Perrella, Steven, *Commercial Value and Hypersurface*, Wojdyla, Henry, *Terry Rosenberg, Generatrix*,
Rosenberg, Terry and Perrella, Stephen with Wojdyla, Henry, *Hypersurface Analysis of Cool World*,
<u>Hypersurface Architecture II</u>, <u>Architectural Design</u> Volume 69, 10/99 PP.38-51

2000 Harrison, Helen A., *Locking Onto Notions of Motion*, <u>The New York Times</u>, 12/31/00

2001 Zimmer, Elizabeth, *Voice Choices*, <u>The Village Voice</u>, 3/27/01

Anderson, Jack, *Thrusts and Stretches Inspire Swirls and Smudges*, <u>The New York Times</u>, 3/28/01

Kendall, Richard, *On Painting Action: An Interview with Terry Rosenberg*, <u>NYARTS</u>, 12/01, PP.69-71

2002 Hassebroek, Ashley, *How Did These Artists Get Here?* <u>Omaha World Herald</u>, 3/31/02

Long, Robert, *At Arlene Bujese*, <u>The East Hampton Star</u>, 8/29/02

BOOKS AND CATALOGS

1980 <u>Maximum Coverage: Wearables by Contemporary American Artists</u>, John Michael Kohler
Arts Center, Sheboygan, Wisconsin

1981 Axel, Jan, and McCready, Karen, <u>Porcelain: Traditions and New Visions</u>, Watson-Guptill, New York
<u>U S Art Now</u>, By Nordiska Kompaniet, Stockholm, and Goteborgs Kunstmuseum, Goteborg, Sweden

1982 Ostrowitz, Judith, <u>Personal Iconography</u>, By OIA, New York, Introduction by April Kingsley
Flood, Richard, <u>Agitated Figures: The New Emotionalism</u>, Hallwalls Contemporary Arts Center, Buffalo,
New York and Hal Bromm Gallery, New York City
<u>Great Big Drawings: Contemporary Works on Paper</u>, The Hayden Gallery, M.I.T., Cambridge Paintings
and Sculpture Today 1982, Indianapolis Museum of Art. Indianapolis, Indiana
<u>UFO</u>, Queens Museum, Queens, New York

1983 Wechsler, Susan, <u>The Raw Edge: Ceramics of the Eighties</u>, Hillwood Art Museum, Long Island University,
C.W. Post Campus, Brookville, New York

1984 Maul, Tim, <u>Terry Rosenberg: Drawings/Sculpture</u>, Frances Wolfson Art Gallery, New World Center, Miami-
Dade Community College, Miami, Florida
Freidrich, Maria, <u>A Passionate Vision: Contemporary Ceramics from the Daniel Jacobs Collection</u>,
DeCordova Museum, Lincoln, Massachusetts

1985 <u>Between Science and Fiction</u>, Sao Paulo Bienal, Sao Paulo, Brazil

1986 <u>Eloquent Object: The Evolution of American Art in Craft Media Since 1945</u>,
Philbrook Museum of Art, Tulsa, Oklahoma
<u>Who's Who in American Art</u>, Editions 17-24
<u>Forum</u>, International Art Fair, Zurich, Switzerland
<u>Terry Rosenberg, Zeichnungen/Drawings, Berlin/New York</u>, Galerie Silvia Menzel, Berlin, Germany, and
Bette Stoler Gallery, New York City

1987 Kingsley, April, <u>The Interior Self: Three Generations of Expressionists View the Human Image</u>, Montclair
Art Museum, Montclair, New Jersey

1991 Neubert, George, <u>Midwest Sculpture</u>, Sioux City Art Center, Sioux City, Iowa

1992 <u>International Who's Who of Intellectuals</u>, 9th Edition, International Biographical Centre,
Cambridge, England
<u>Alien Encounters, Mysteries of the Unknown</u>, Time-Life Books, Alexandria, Virginia

1993 Madra, Beral, <u>Terry Rosenberg, Projections</u>, BM Contemporary Art Center, Istanbul, Turkey

1994 Hogrefe, Jeffrey, <u>Terry Rosenberg, Drawings</u>, Inside the Dance, Sheldon Memorial Art Gallery,
Lincoln, Nebraska
Beylerian, George M., <u>Chairmania</u>, By Harry N. Abrams, New York

1995 Rosenberg, Terry, <u>Generatrix</u>, UNO Editions, University of Nebraska, Omaha, Forward by
Daphne Anderson Deeds

1999 Perrella, Steven, <u>Hypersurface Architecture II</u>, By Architectural Design

2000 Shaw, Karen, <u>The Notion of Motion</u>, Islip Art Museum, East Islip, New York
Sangster, Gary, <u>Snapshot</u>, Contemporary Museum, Baltimore, Maryland

2002 <u>Decimo Aniversario</u>, Museo De Arte Contemporaneo De Oaxaca
<u>Figuring Motion: Terry Rosenberg</u>, Smart Art Press, Essays by Richard Kendall and Linda Nutter PH. D., CMA

EDUCATION

1974 AA Miami Dade Community College, Miami, Florida

1976 BFA University of Miami, Coral Gables, Florida

1978 MFA New York State College of Ceramics, Alfred, New York

MUSEUM COLLECTIONS

Addison Gallery of American Art, Andover, Massachusetts

Albright Knox Art Gallery, Buffalo, New York

Arkansas Arts Center, Little Rock, Arkansas

Asheville Art Museum, Asheville, North Carolina

Berkeley Art Museum, University of California, Berkeley

Boca Raton Museum of Art, Boca Raton, Florida

Brooklyn Museum of Art, Brooklyn, New York

Cabinet des Estampes et des Dessins, Liege, Belgium

David and Alfred Smart Museum of Art, University of Chicago, Illinois

Fine Arts Museums of San Francisco, California Palace of the Legion of Honor, San Francisco, California

Graphische Sammlung Albertina, Vienna, Austria

Jane Voorhees Zimmerli Art Museum, Rutgers University, New Brunswick, New Jersey

John and Mable Ringling Museum of Art, Sarasota, Florida

John Michael Kohler Arts Center, Sheboygan, Wisconsin

Joslyn Art Museum, Omaha, Nebraska

Kemper Museum of Contemporary Art & Design, Kansas City, Missouri

Library of Congress, Washington, DC

Montclair Art Museum, Montclair, New Jersey

Montgomery Museum of Fine Arts, Montgomery, Alabama

Musee d'Art Moderne et d'Art Contemporain, Nice, France

Museo de Arte Contemporaneo de Oaxaca, Mexico

Nelson Atkins Museum of Art, Kansas City, Missouri

Schein-Joseph International Museum of Ceramic Art, Alfred University, Alfred, New York

Sheldon Memorial Art Gallery and Sculpture Garden, Lincoln, Nebraska

South London Gallery, London, England

Spencer Museum of Art, University of Kansas, Lawrence

The Art Museum, Florida International University, Miami, Florida

University of Iowa Museum of Art, Iowa City

Virginia Museum of Fine Arts, Richmond, Virginia

Walker Art Center, Minneapolis, Minnesota